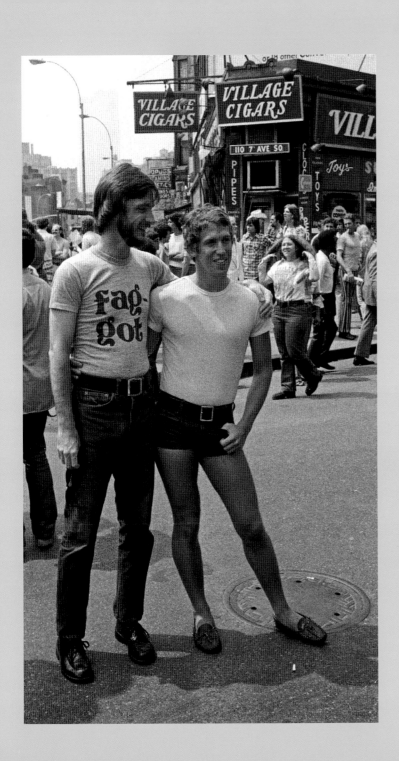

Gay
Day

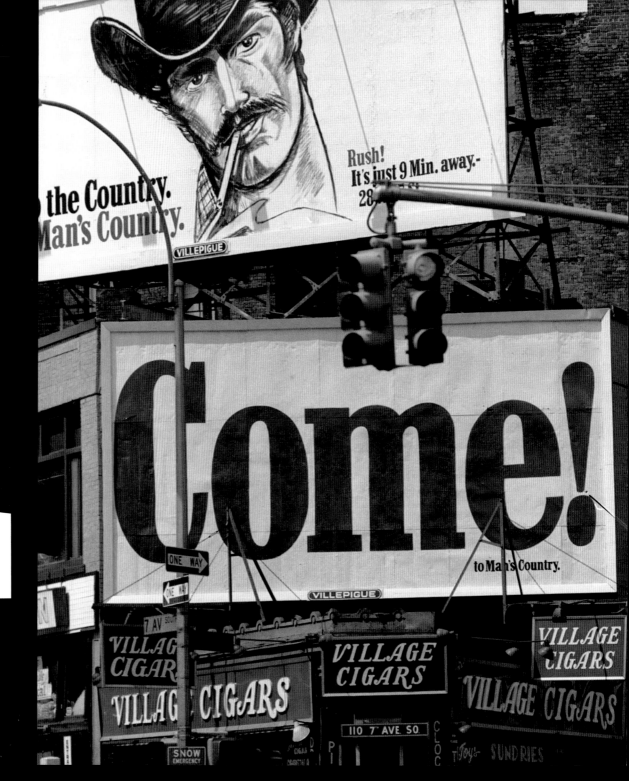

Gay
Parade begins
at the center of the official
U. S. Dope Trade.

Gay Day

The Golden Age of the Christopher Street Parade 1974-1983

Photographs and Introduction by HANK O'NEAL

Captions by ALLEN GINSBERG

Preface by WILLIAM S. BURROUGHS

Afterword by NEIL MILLER

ABRAMS IMAGE
NEW YORK

ACKNOWLEDGMENTS

Many people were helpful during the past thirty-plus years from the time my first pictures were taken to this book in its final form. Liza Stelle developed my film in the early 1970s, and maybe even handled it as late as 1977. Allen Ginsberg was always very supportive, as was William Burroughs. I'm sure it was William's close associate James Grauerholz who made certain the preface was completed, and I know it was James who sent it along to me.

More recently, others have been very helpful. Bob Rosenthal and Peter Hale from the Allen Ginsberg Trust helped to make everything flow smoothly and were particularly helpful with making certain that all the captions were correct. In a few instances, when Allen's handwritten captions were set in type they were changed slightly for the sake of consistency and clarity. Howard Greenberg and Shelley Shier were constant sources of encouragement, as was Jennifer Stroup, who made hundreds of test prints. There would be no book without the support and enthusiasm of Alex Glass of Trident Media and Howard Reeves and Stan Redfern at Abrams. Ed Miller's wonderful book design is much appreciated and Neil Miller's perceptive afterword put everything in proper perspective. Final thanks must be given to Ian Clifford, who scanned all my negatives, made them look better than they did when I took them thirty years ago, saved various images that were under- or overexposed, enhanced Allen's captions so that they could be read with ease, and created all the digital files needed for this book. All these people deserve much credit in bringing this book to fruition.

Designer: Edward Miller
Production Manager: Kaija Markoe

Library of Congress Cataloging-in-Publication Data has been applied for.
ISBN 0-8109-5508-3

Printed and bound in China
10 9 8 7 6 5 4 3 2 1

HNA
harry n. abrams, inc.
a subsidiary of La Martinière Groupe

115 West 18th Street
New York, NY 10011
www.hnabooks.com

Anybody who says there have been no real changes effected by the cultural revolution should look at this book. Gay is now a household word. Well, it wasn't fifty years ago, when I was a kid. In those days a Hispanic was a Mezican, a Black a nigger, and a gay person was a fucking queer. The idea that Mezicans, niggers, and fucking queers had any rights at all was simply ridiculous. Oh sure, people knew it happened. . . *have my doubts about Greg and Brad who run the antique store, but so long as Greg and Brad keep shut up about it, it's all right. You know, gentleman's agreement. But when they start shoving it in our faces, well . . .*

So they did shove it in people's faces and they won. All it took to get underway was one stand by one intrepid band who said, *We will not take this crap any longer!* I refer to the heroes of Stonewall, who were the first to raise the banner of freedom and who led the way for the gay parade to follow. Time marches on . . . the gay parade marches on.

William S. Burroughs
Lawrence, Kansas 1984

5

INTRODUCTION

I first became aware of the annual Gay Parade in 1973, shortly after I'd built a recording studio at 173 Christopher Street. It was a Sunday night in late June. I'd been away for four or five days and returned to find my block filled with thousands of people, a festive block party, with no holds barred. I asked someone what was going on and was told that this was the annual Gay Parade, winding down.

A year later, another Sunday late in June, but now it was morning, a day to sleep in after a long week, I was awakened by what sounded like a gathering crowd in the street, a noisy gathering crowd, a crowd equipped with hammers and portable cassette players. I looked out the window and saw a gathering crowd, a sizeable one. At first I didn't know what was going on, but it didn't take long to realize that the annual Gay Parade was being organized in my front yard, the long, wide block of Christopher Street between Washington and West Streets.

I looked on in amazement, finally went outside, and was quickly caught up in all the good spirits and activity, as various marchers and assorted groups assembled.

I took my camera along and began to take photographs. This was an exciting, highly spirited event, one that lent itself to casual and candid photography. The marchers were bursting with energy and enthusiasm, an enthusiasm matched by the onlookers, who later crowded the Christopher Street sidewalks and cheered the passing procession.

The parade eventually grew to enormous proportions and today has a name almost as long as Christopher Street: The Annual Lesbian, Gay, Bisexual, Transgender PRIDE March. But when I first became aware of it, people I knew in the neighborhood simply called it the Gay Parade, even though then it had the official title of the Christopher Street Liberation Day March. Later, when I met Allen Ginsberg, he always called it the Gayday Parade. But in those years, attendance was decidedly modest, both in terms of marchers and onlookers; the photographs attest to this fact.

I wandered back and forth between Hudson Street and Sheridan Square but never followed the parade as the marchers proceeded north, out of Greenwich Village, where I presumed the reception

would probably be less positive. But on Christopher Street, the parade seemed almost innocent in its spontaneity and was positively bucolic, with people on the sidewalks interacting with people in the street, and vice versa. As the years passed, I was a happy observer of as many parades as possible, with my camera in hand and my pockets jammed with rolls of Tri-X.

I continued to photograph the parade into the early 1980s, though with less enthusiasm than in earlier years. By 1983, the last year I took photographs, it was forming uptown and had become a far more formal, well-organized event. It was harder to find a good, spontaneous photograph. The parade was now an event, one covered by all the media, and much of it was structured for media consumption. The people who planned the parade knew exactly how to work the coverage to their advantage. The demonstrations outside St. Patrick's were perfectly choreographed, probably right down to the people who would be arrested.

Eventually, the one-day parade expanded to become Gay Pride Week and a week-long party, during which the Empire State Building was bathed in lavender lights. All this activity was extremely positive, bringing attention to the fact that the road to gay equality was still a very rocky one. And even today there is much that needs to be done. But to me, as something of an outsider, the rough-and-tumble quality of the parade in the early years has always remained far more interesting, particularly from a photographic standpoint.

This book has had a strange evolution. By 1979 I had hundreds of photographs of various parades and, by chance, an editor friend, Les Pockell, saw some of them one day. We'd just put the finishing touches on a reissue of Djuna Barnes's 1928 novel *Ryder*, and his firm was very optimistic about the book's possibilities. I'd also completed three other projects for him that had been successful, so I was not surprised when he suggested that it might make sense to assemble the best of my photographs and to produce a small book, a modest visual history of what the march looked like in the mid-1970s.

At the time, except for a handful of images, I hadn't shown these photographs to anyone except Djuna Barnes. And the only reason I'd shown them to her was because one day she'd commented on the noise that she'd heard from one of the parades. At the time, she was confined to her Patchin Place apartment, just a step or two from the Avenue of the Americas, the uptown route of the parade in those years.

7

Miss Barnes expressed an interest in learning about what was going on, and when I told her that I had photographs of the parade, she was eager to see them. The photographs didn't please her, and she disapproved of the idea of the parade once she'd seen them. Later, when I told her that I'd been discussing using some of them in a book, she was horrified, exclaiming that I shouldn't even consider such a thing, and that such a book would ruin my reputation.

Of course, it didn't matter what Barnes or I thought as the only thing that mattered was the opinion of the publishing company. And despite the success I'd had with earlier books, in 1979 St. Martin's Press was not ready to publish a book about a localized event in New York City, especially one that just included a bunch of seemingly ordinary, sometimes costumed, but mostly unadorned people marching on Christopher Street. I couldn't really blame them, so I put the images away for safekeeping. But I kept taking pictures for myself, just with a little less enthusiasm.

This book now exists because in 1982 I met Allen Ginsberg. A year earlier, I'd been one of the founders of Hammond Music Enterprises, along with the legendary producer/talent scout John Hammond, and venture capitalist John Moore.

Hammond had always wanted to release an album of Allen's music, but his former employer CBS wouldn't stand for it. They felt that Allen, and most of his songs, were obscene. But now John had his own label and even though CBS distributed it, they could no longer dictate what would be released. One day in early 1982, John invited Allen to our offices, and it was then that we began to structure the album that was eventually released the next year as *First Blues*.

In those years, Allen was increasingly interested in the performance of his poetry, preferably with music; but his interest in photography was also blossoming, through his friendship with Robert Frank, and his introduction by me to Berenice Abbott. He and I spent a good deal of time together organizing *First Blues*, and when we took a break from the album, as often as not, we'd talk about photography—particularly if we were working at my office at 830 Broadway. There were many hundreds—thousands, in fact—of photographs at 830 Broadway. They were in boxes, frames, or sometimes less suitable conditions. Allen wanted to look at everything, and at some point, he came upon the box of photographs I'd taken at various Gay Parades.

I told him about my experience in 1979. He said that was silly, that I shouldn't

worry about it, and that besides, he liked the pictures. He suggested he would be interested in writing captions for them. There must have been at least one thousand images by 1982. With Allen's assistance, I picked out about 120, the ones we thought were the best, or at least the most interesting from his point of view. He then captioned these photos during three marathon sessions in early 1983. Later, after the parade that year, he selected a few more and wrote captions for those, too.

Our process was remarkably simple. I'd go to Allen's apartment on East 12th Street and telephone from the corner or yell from the street. The window would open; Allen, Peter (Orlovsky), or whoever might be visiting would stick out his head to see who it was and throw down a sock with a key. Allen may very well have come to 830 Broadway for a captioning session, I don't really remember, but either way we got the job done. How did it work?

Allen would look at a photograph, and as he thought about the image and responded to it, would simply write down the first thing that came into his mind. His mantra was first thought, best thought, and for the most part, he stuck to it. The process was much like improvisational jazz, an analogy that probably would have pleased him. He was very quick, very clever, and

always to the point. He wrote most of the captions in pencil and rarely, if ever, changed anything. He would cross out a few words here and there, but that was the extent of the changes.

A few months later, William S. Burroughs was in town to celebrate his seventieth birthday. Shelley Shier and I turned 830 Broadway over to him and a bunch of his pals to use as a base of operations. I camped out uptown at Shelley's apartment but usually was downtown at least once a day, just to check on things, and to take part in the good times that were always in progress.

One day I arrived to find William had signed all my copies of his books; on another day I witnessed (and photographed) target practice. With a high-powered pellet gun, he shot up a copy of a twelve-inch single by a group that called themselves Three Teens Kill Four. I got in a few shots myself, but William hit the target with far more accuracy than I did. Whether he was shooting a pistol or not, the many contact sheets from the week that he was in residence are still fascinating.

I showed William the parade photographs, along with Allen's captions, and explained our idea for a book. He said that he'd happily be involved in the project. I gave him copies of many of the photographs, and a few months later, a short preface arrived in the mail. (The photograph of William with Allen that appears on the next page was taken when William was in residence at 830 Broadway.)

I had a new burst of enthusiasm for the project and so took more photographs during the 1983 parade, including a few uptown, just for some contrast. The parade couldn't have been more different in 1983 than it was in 1974. And while I observed some parades in later years, I never took another photograph of the event. It was, by then, very well covered. (In the early years, there weren't that many people with cameras following the parade downtown, at least on west Christopher Street.) A few of these later images are not captioned. Through Allen and I had agreed on which should be included, when the project fizzled, they were left undone.

My idea, naïve as it may seem, was to produce the raw materials for a modest book of photographs, which would include William's short introduction and Allen's wonderful captions. We all agreed that if we could find a publisher, royalties would be donated to an organization doing AIDS research. Everyone associated with the project knew that this was only a modest gesture—we had no illusions that what we were doing would produce buckets of money—but the gesture was sincere.

Needless to say, nothing worked out with the book. Unfortunately, in 1983 most people outside the gay community didn't know or care about AIDS, and the proposed book seemed to frighten all potential editors and publishers, gay or straight. It may be hard to remember, but in those days, AIDS was a topic that wasn't discussed in polite society, or even in the *New York Times*. It didn't take us long to get the idea that no one was ready for a book such as this, so the project was abandoned.

Allen and I were dismayed by this unexpected turn of events, and the photographs and captions went back on the shelf, again to be forgotten. Allen later mentioned the book once or twice, but he had other priorities, and I had other projects to undertake: festivals to produce, new recordings to make, and new photographs to take.

Fast forward to 1997, when I began creating a new introduction from my 1983 essay. I'd pulled the essay out because both Allen and William had died that year. I heard about Allen when I was in Australia, William when I was in England. I wasn't surprised by either death—Allen had been in failing health for some time, and that William had managed to live such a long and productive life was simply

9

10

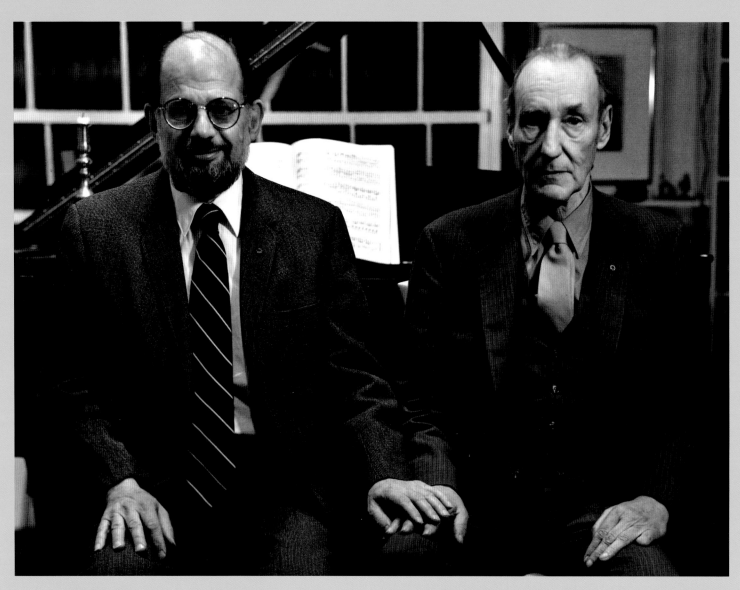

Allen Ginsberg & William S. Burroughs, 830 Broadway, New York City, 7 February 1984

astounding (but even with his ironclad genetic makeup, he could only last so long).

As an exercise I reworked the introduction, but I still hadn't looked at the box of parade photographs for years. By then, the photograph I had taken in 1984 of Allen and William holding hands was thirteen years old, almost old enough to qualify as a vintage print. Some of the other photographs were nearly a quarter-century old. They did qualify. In fact, most of the photographs selected for reproduction in the book are from the 1970s. Then I put the photographs and the reworked introduction back on the shelf and did nothing with them.

This is part of what I wrote in 1997:

Today, I look at the faces of these mostly cheerful, optimistic people, men and women clearly having an exciting time on a hot June or July day long ago. I wonder how many are dead today, having died long before their time, and how many might still be alive. What might have happened if people hadn't looked away in the early 1980s because of bigotry, commercial interests, or just plain stupidity? What if it hadn't been so hard to launch AIDS-related research projects, or even just tell the truth and educate people? I'm not so naïve as to believe that anything generated by a little book of photographs would have made any difference or saved anyone. But if our country hadn't been populated with so many narrow-minded, ignorant moralizers, who were represented by pandering, spineless politicians (from presidents on down), who in turn funded inept, time-clock-locked bureaucrats charged with overseeing greedy pharmaceutical companies, much of the progress that had been made by 1997 in combating AIDS might have been made earlier.

If these people had not slowed things down in the beginning, some of the faces in these photographs might still be smiling, their owners marching in the parade today. Unhappily, most of the ignorant and narrow-minded people (or their descendants), who impeded research and education at the beginning of the epidemic, are still out there, still looking for other ways to cause trouble. The next time a serious health issue arises, one that involves the same mixture of sexuality and what the family-value crowd views as questionable morality, they'll mess things up again. They always do.

Now it's eight years since I wrote those words, and while perhaps they're overly dramatic, that was the way I was feeling then. Then something happened in early 2005. I took the photographs off the shelf and showed them to Alex Glass. He understood immediately, felt it was a good project, and urged me to prepare a short presentation booklet. He showed the booklet to Howard Reeves at Abrams. Howard also got it.

Twenty-two years after the fact, perhaps the time has finally come. I know there are some people who may find everything in this book offensive, and then go to church before they shoot their neighbor, but these are the same people who strive to keep countless classics off library shelves for one reason or another. Thankfully, for the most part, times have changed.

That it took so long for these photographs and captions to make it into print does have an upside, because we're now able to do a much more visually interesting book. Technology has made it possible to remove Allen's captions from the back of the photographs, and with the help of Adobe Photoshop, to transfer them to the front. The photographs then became much more personal. We also were able to clean up some of the negatives that suffered from poor exposure and shaky 1973 developing techniques and to make them far better for reproduction. Maybe the wait will have been worth it, except for those who didn't have that much time left.

Hank O'Neal
New York City 1979–2005

11

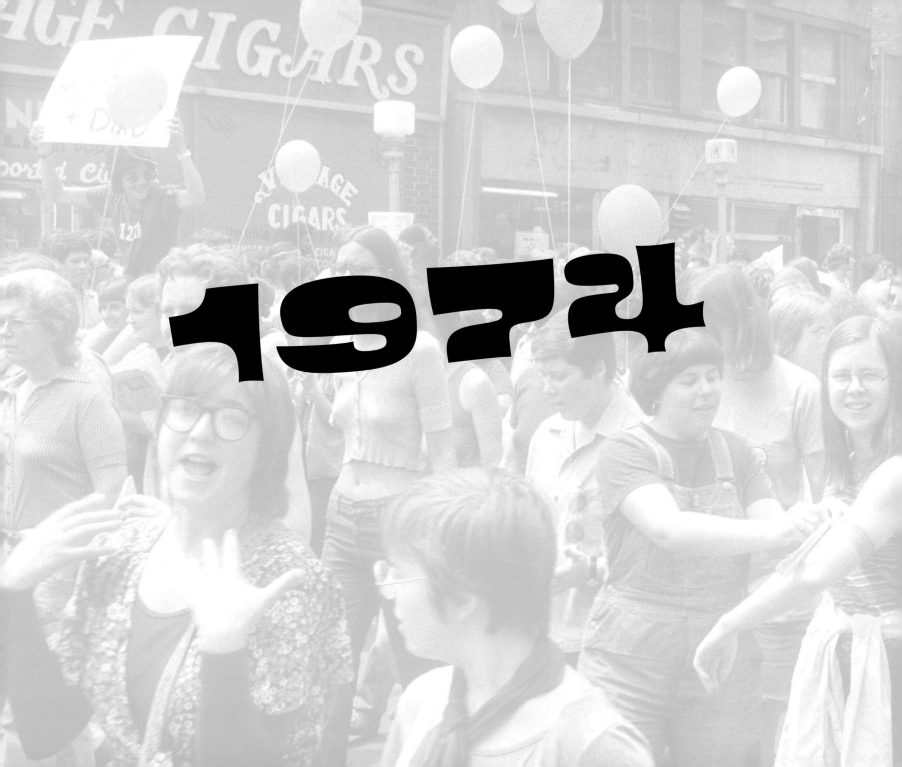

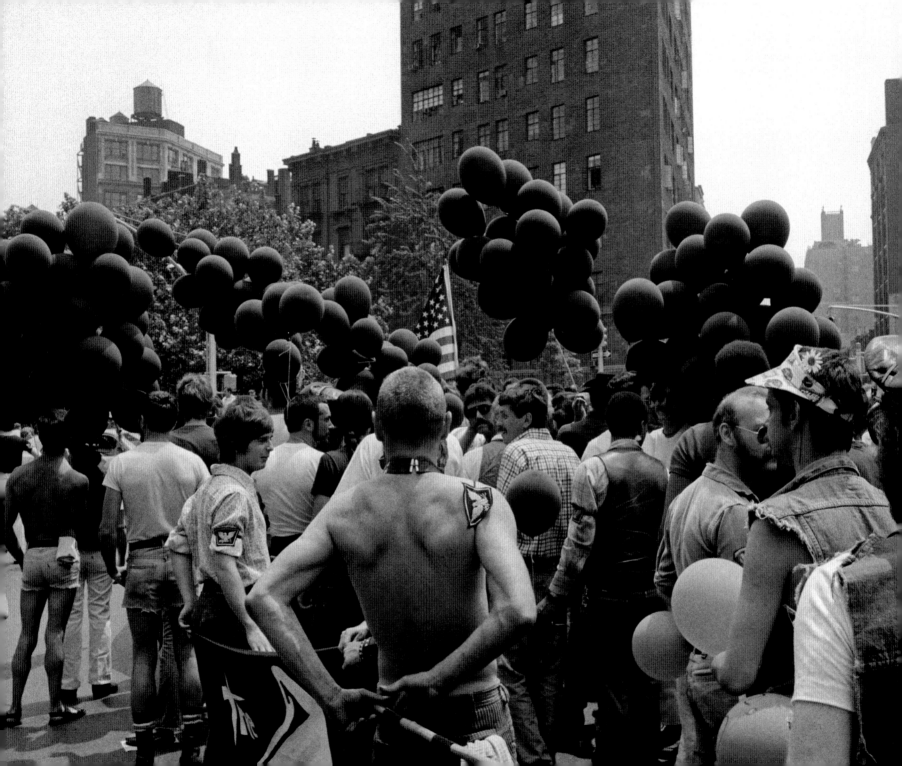

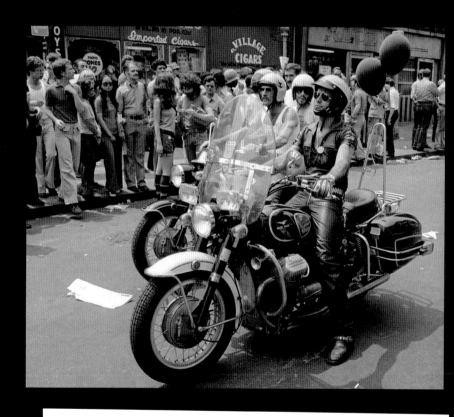

Eagle Angels with slave collars come out early year's marches

Eagle Angels with slave collars come out
to early year's marches

Looking like cute highway patrolmen
. . . don't see 'em much in the
gayday parade lately . . .

looking like cute highway patrolmen
. . . don't see 'em much in the
gayday parade lately . . .

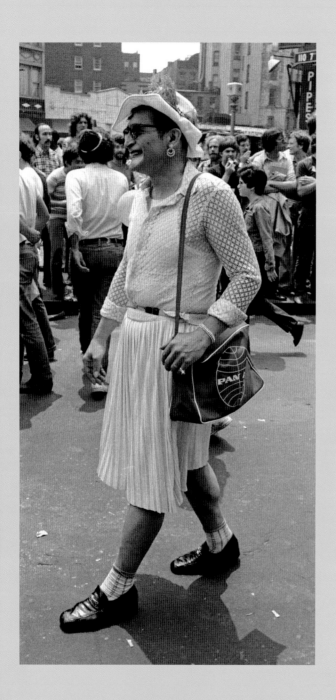

16

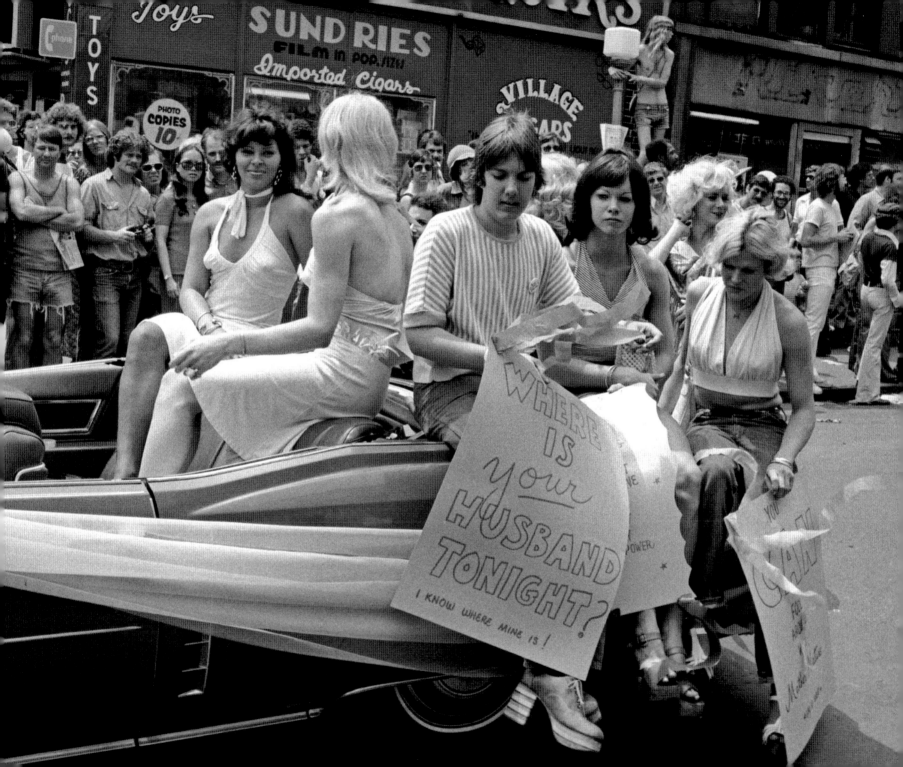

Blacks are most truthful,
it all goes back to
African religious dignity.

18

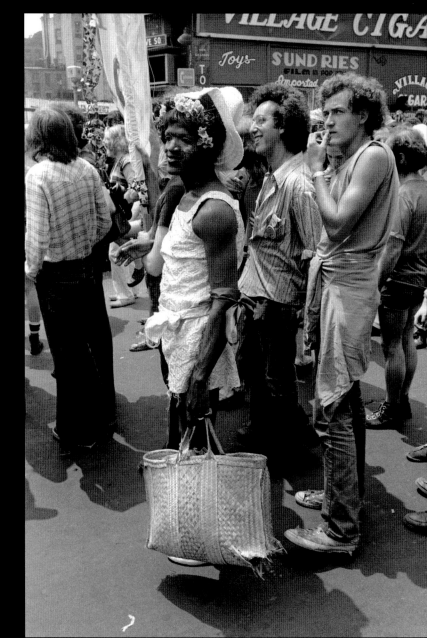

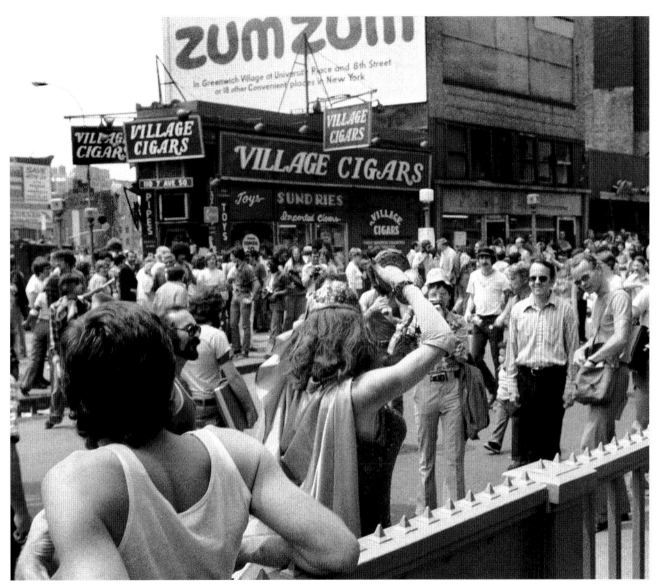

Everybody's in my hair!

Everybody's in my hair!

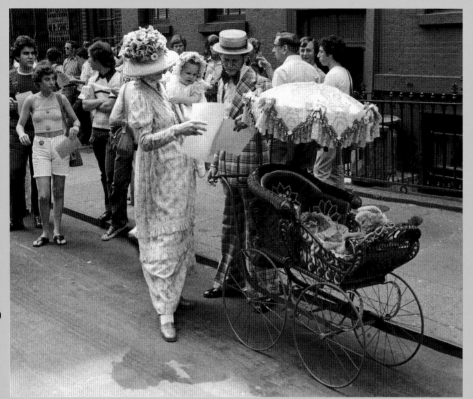

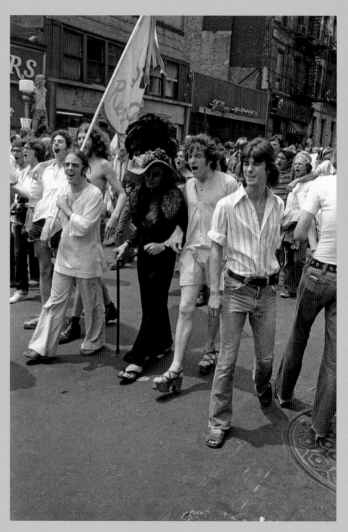

"I wanna girl just like the girl that married dear old dad."

"I wanna girl just like the girl that married dear old dad."

Judy Garland's got big-veined fists & activist boyfriends singing

Judy Garland's got big-veined fists & activist boyfriends singing.

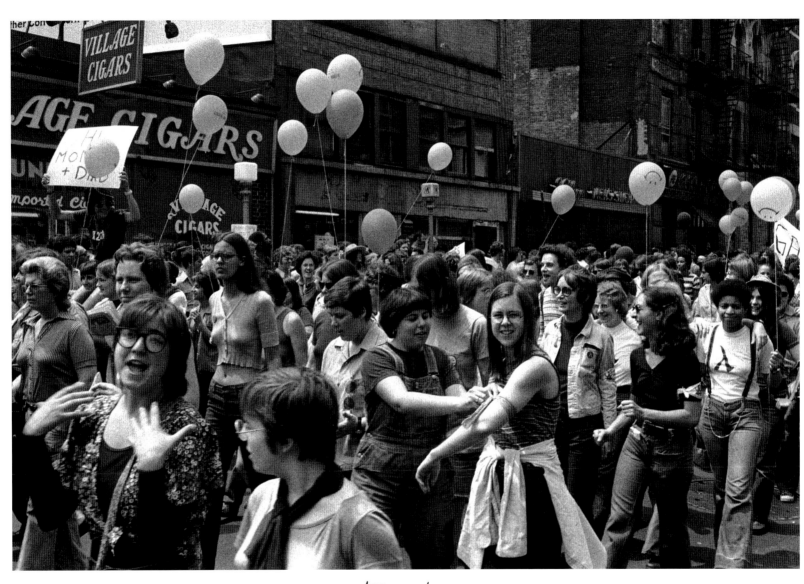

21

~~First~~ a big crowd of boys + girls + matrons — but that tall girl looks worried, doesn't she have a ~~the~~ baloon?

A big crowd of boys & girls & matrons—but
that tall girl looks worried, doesn't she have a
balloon?

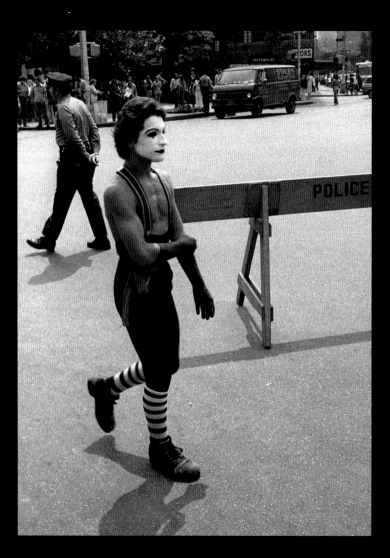

22

*Rolling up his sleeves to get
to work, except he's got no
sleeves but gloves to his elbows
& harlequin face paint passing
behind police barricade.
Sheridan Square, N. Y.*

*"Let the straight flower bespeak its purpose in
straightness
to seek the light.
Let the crooked flower bespeak its purpose
in crookedness
to seek the light.
Let crookedness and straightness bespeak the light."*

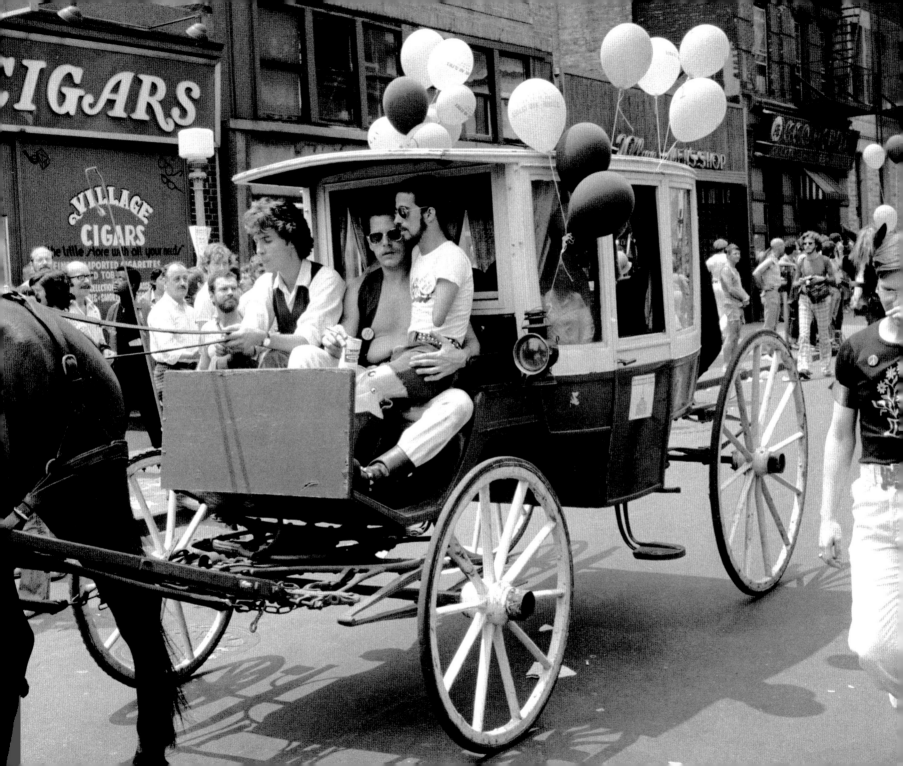

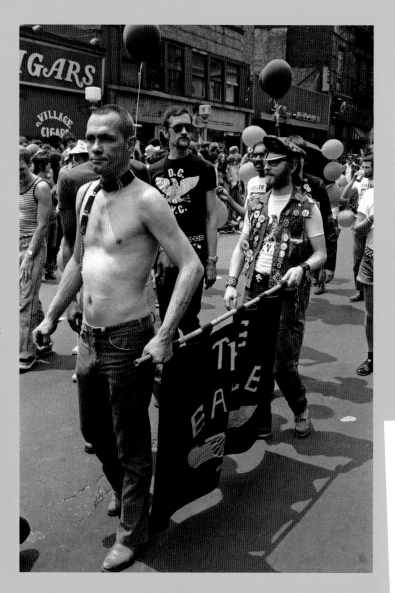

24

Out of the Anvil's basement
with their healed-over scars, banners
& chains.

Resolute parents that have gone through the mill
& seen the skeleton in the closet & come out of the
gruesome funhouse into the light—now they're on their feet
older & dignified, with house dresses & majestic walrus
mustaches.

Motorcycle guys with black balloons.

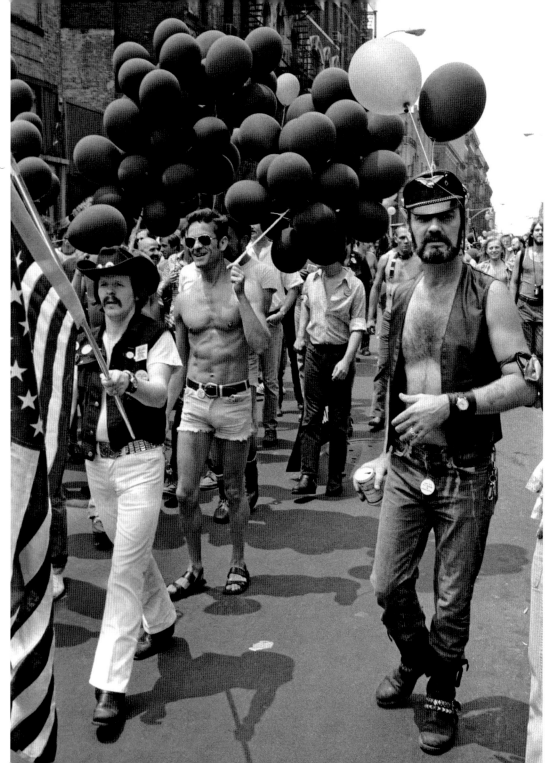

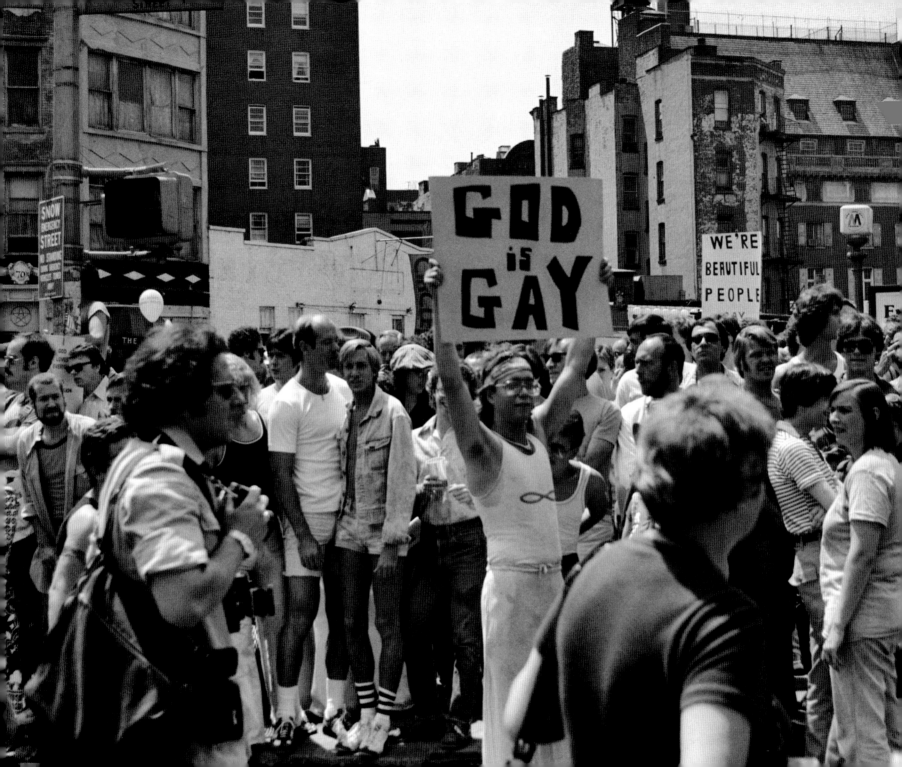

According to Barbelo-Gnostic theory,
God reflected on himself & thus shone Sophia,
the first word-thought, who thereat made sex
with herself and birthed the first Aeon,
Ialdabaoth.

30

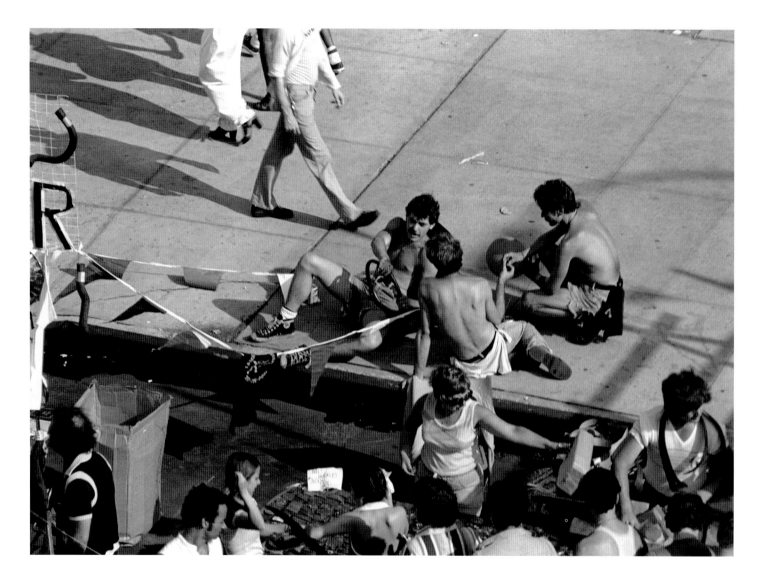

So I turned to the left, passed the joint, & smoked a balloon sitting at the curb, having a good time, goodlooking guys enjoying the sidewalk.

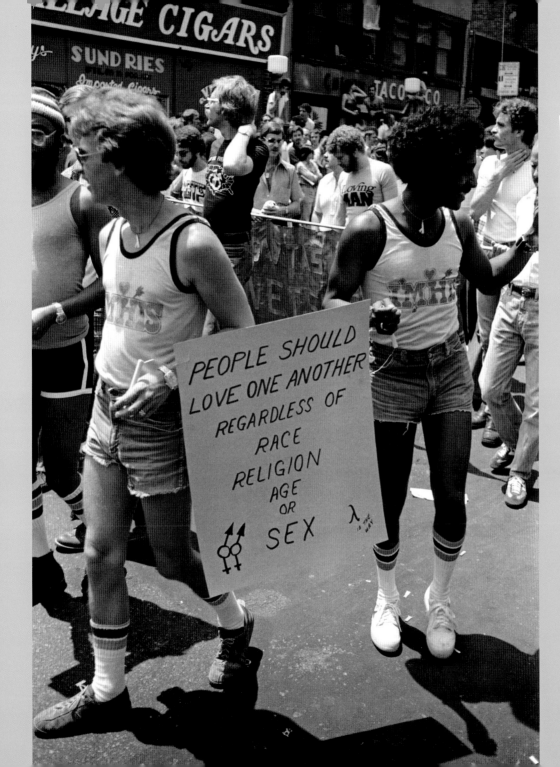

Well I'll take 2 of these & 3 of those.
How old did you say you were?
Does that mean I have to sleep with 90 year
old girls?

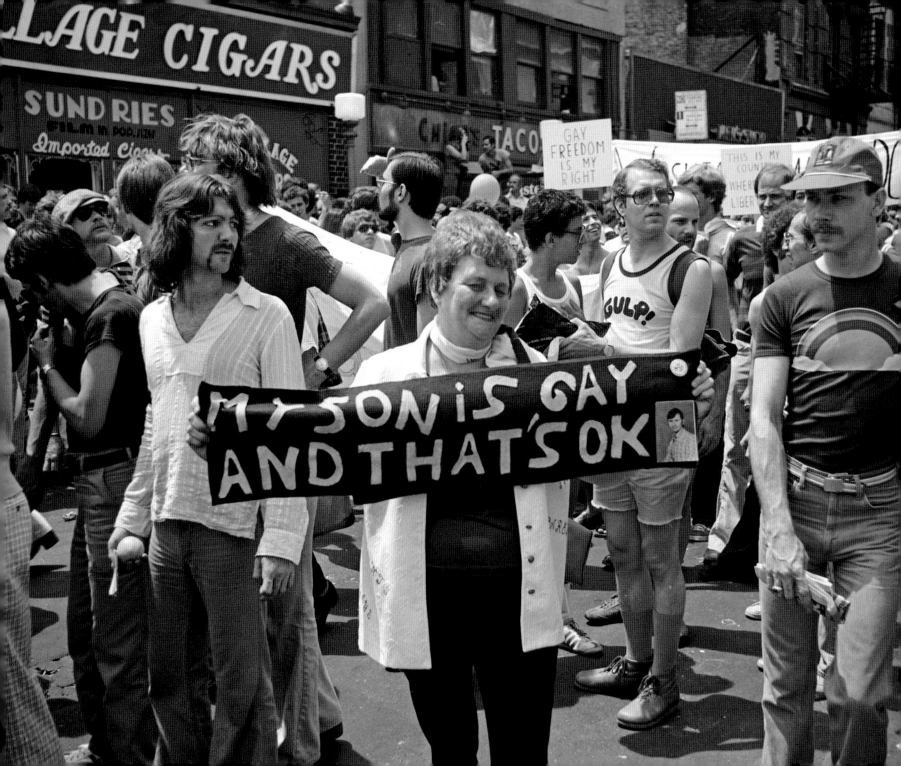

Eager hands grabbing for Gay propaganda in 1975 [sic].

Eager hands grabbing for Gay propaganda in 1975

She's an old anarchist from the 30's. She read Marcel Proust in the slums of Barcelona. She used to be a movie star in Berlin in 1923. Now she lives in Queens in disguise as a typical American mother.

She's an old anarchist from the 30's. She read Marcel Proust in the slums of Barcelona. She used to be a movie star in Berlin 1923. Now she lives in Queens in disguise as a typical american mother.

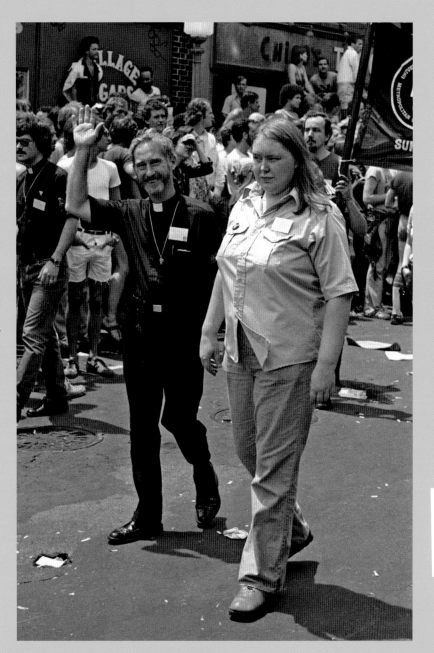

34

A man of the cloth with a postcard
from Christ in his pocket, and Mary
Magdalene wearing her Spiritual Lib
button.

A man of the cloth with a postcard
from Christ in his pocket, and Mary
Magdalene wearing her Spiritual Lib
button.

The one combing his hair with the rippling
muscles made love to me 24 hours ago like a king.

The one combing his hair with the rippling
muscles made love to me 24 hours ago like a king.

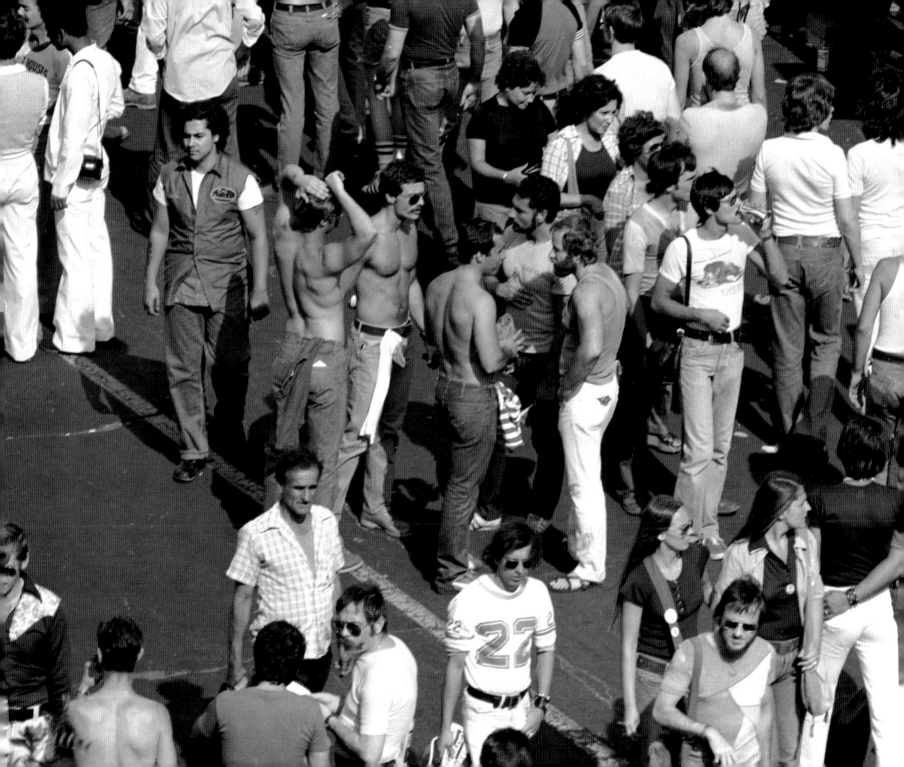

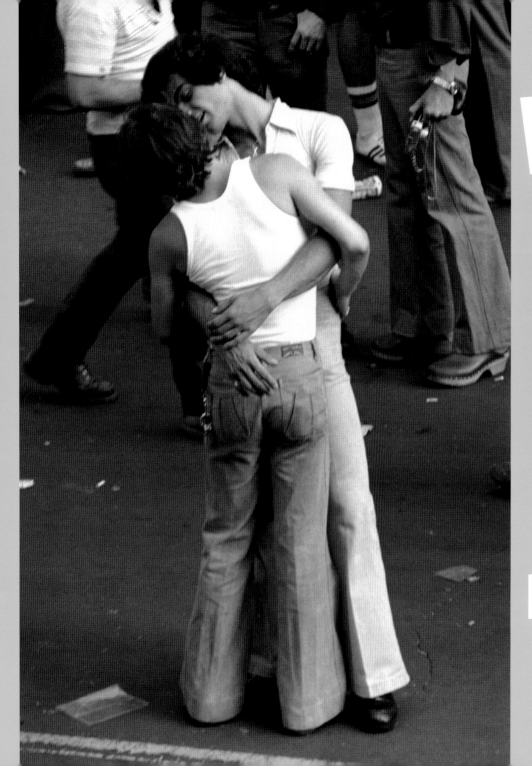

36

Young meat Catholics
appreciating each other's
summery mouths.

When's the last time anybody kissed you
on the belly, really gently?

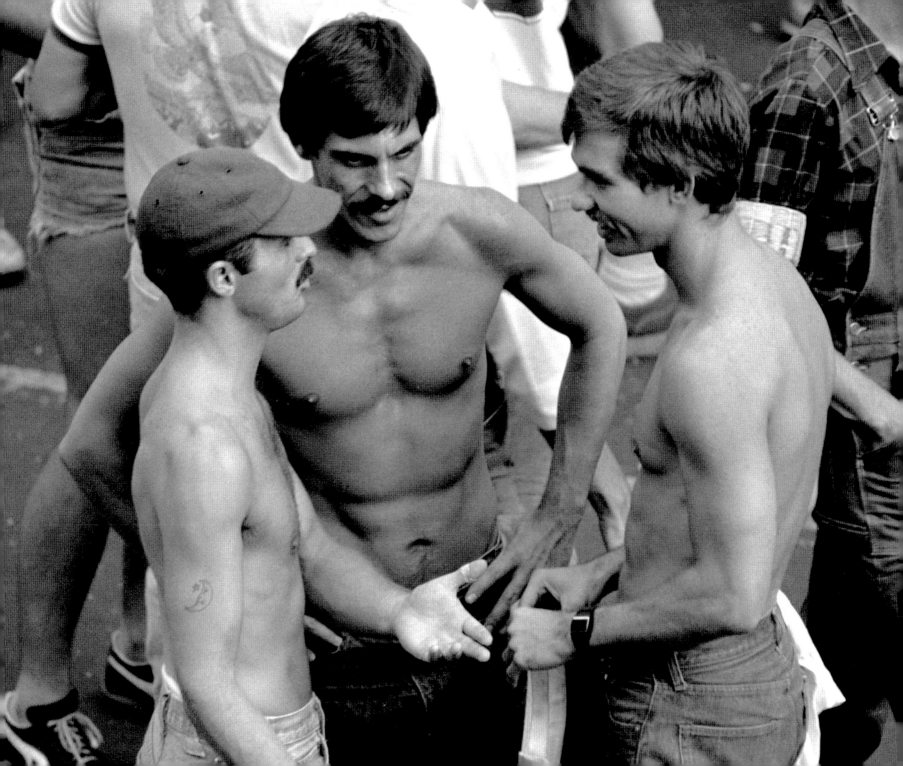

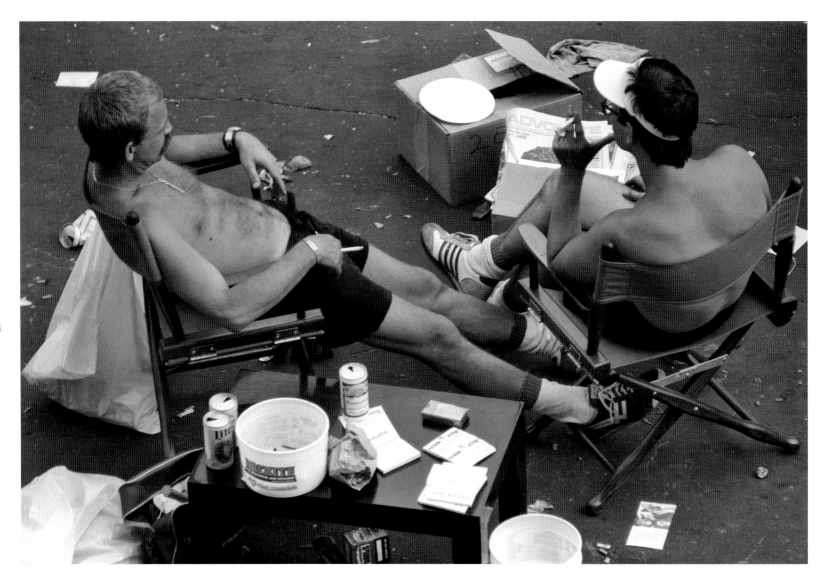

38

One more beer and I'll get a beer belly. Urp.

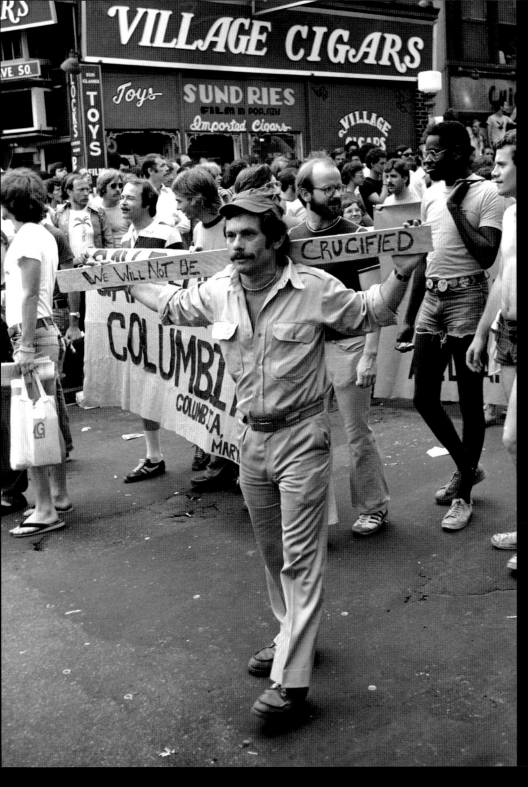

Wait a minute! He's already
carrying the cross.

39

I'm the guy that ~~throw~~ throws pies at Senator Daniel Moynihan.

I'm the guy that
throws pies
at Senator Daniel
Moynihan.

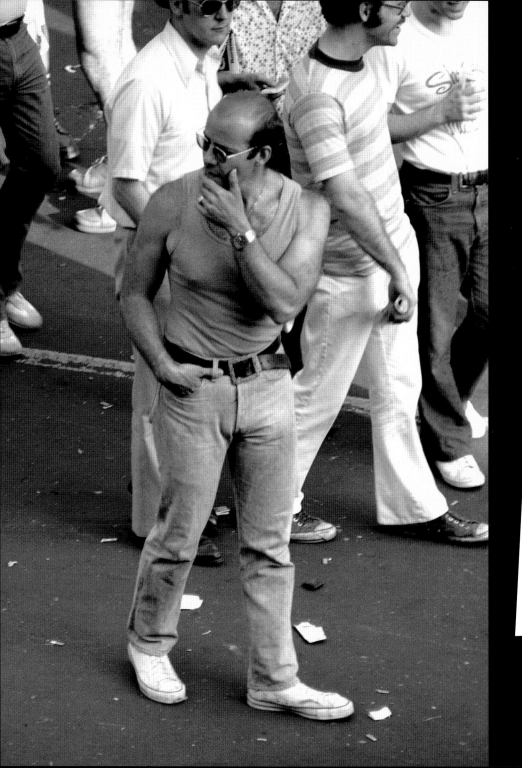

Do you think that little boy would like my big black belt?

Do you think that little boy would like my big black belt?

Look at that funny kid praying to the Bishop drinking reactionary beer—that I dare not speak its name.

Look at that funny kid praying to the Bishop drinking reactionary beer—that I dare not speak its name.

42

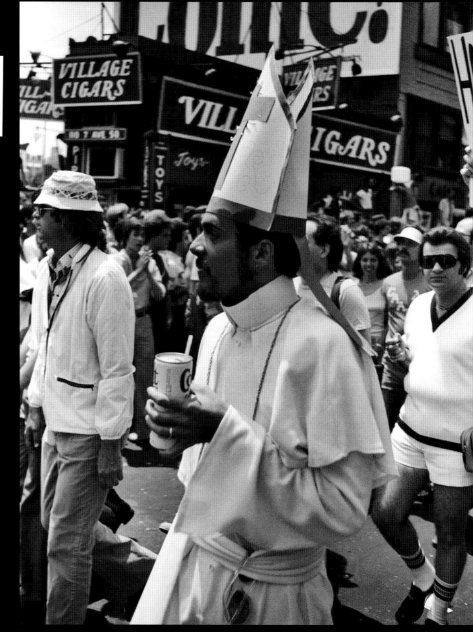

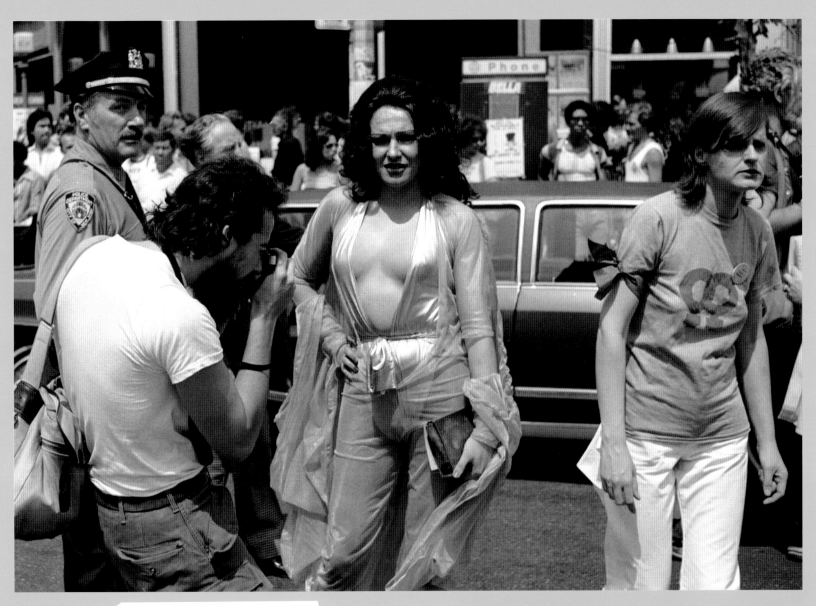

43

Cops with personal mustaches, skin photogs, big tit guys in pancake suffering their own vision in the sun, and a thin socialist dyke.

(with personal mustaches,
Cops skin photogs, big tit guys in pancake suffering
their own vision in the sun, and a thin socialist dyke.

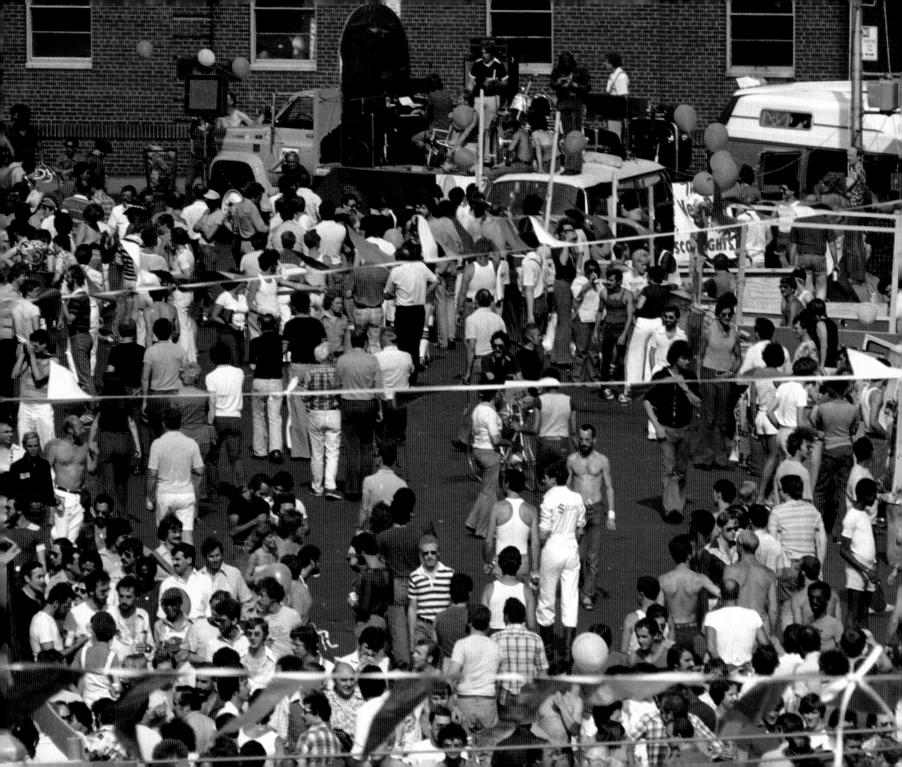

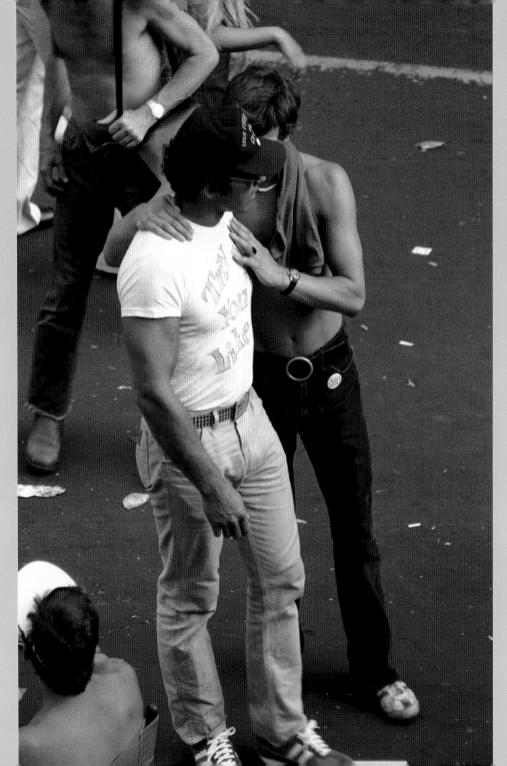

Now if you'll only
listen to me we
could live together
forever
(till we die).

45

Everyone's expecting an orgy in another 10 years.
Some of them have their shirts off already.

We're safe! the world's full of
fairies! lets have a baby.

We're safe! The world's full of
fairies! Lets have a baby.

46

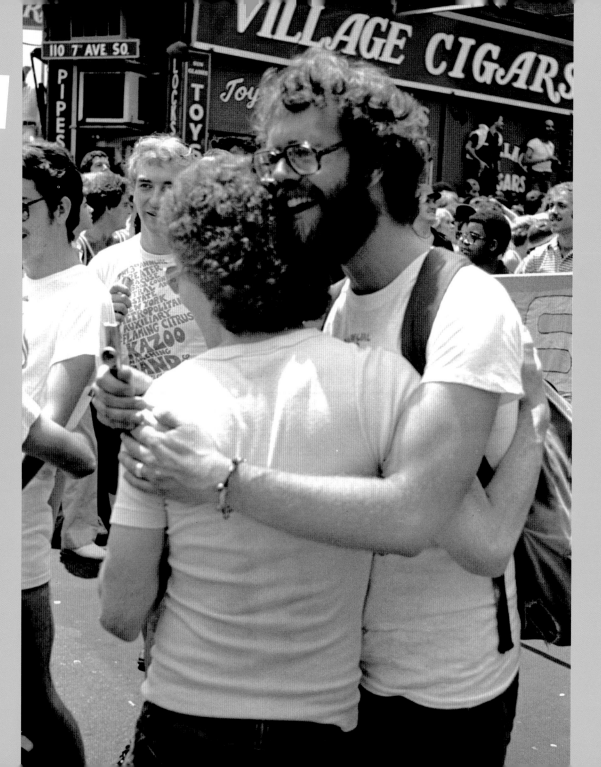

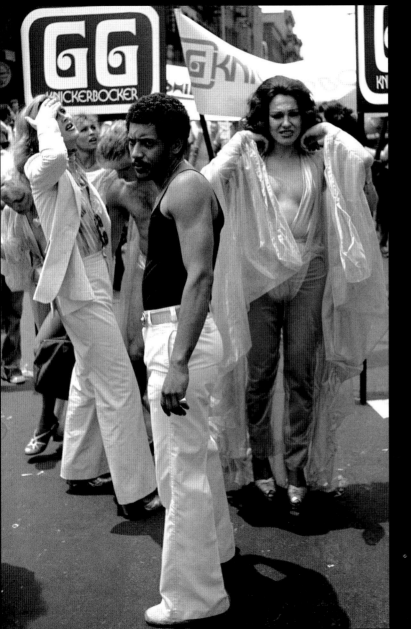

Oh it's just to sweaty even in this gauze feminine, and my god! my god! somebody's jumping out the empire state building inside the gymnasium. These girls are all crazy, I'm not sure I belong here

Oh it's just too sweaty even in this
gauze feminine, and my God! My God!
Somebody's jumping off the Empire State
Building inside the gymnasium. These girls
are all crazy, I'm not sure I belong here.

47

Anita O'Day is still singing.

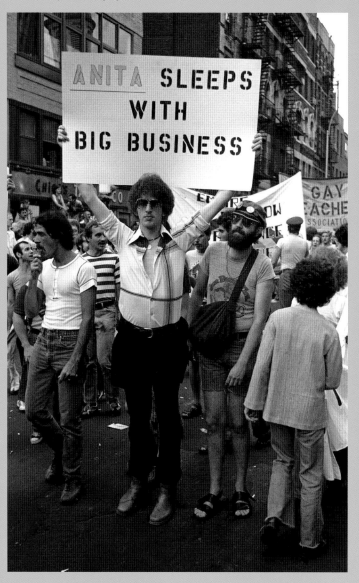

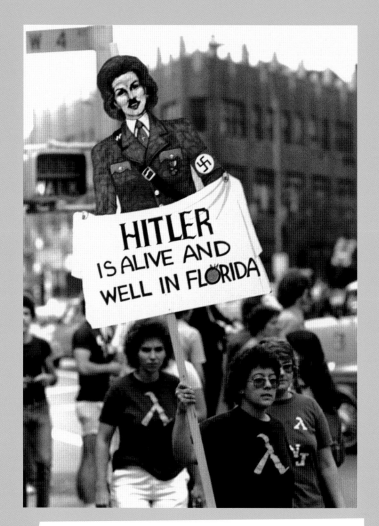

That's alright honey she'll
get a divorce in ten years
& say her husband was a lousy
fuck anyway.

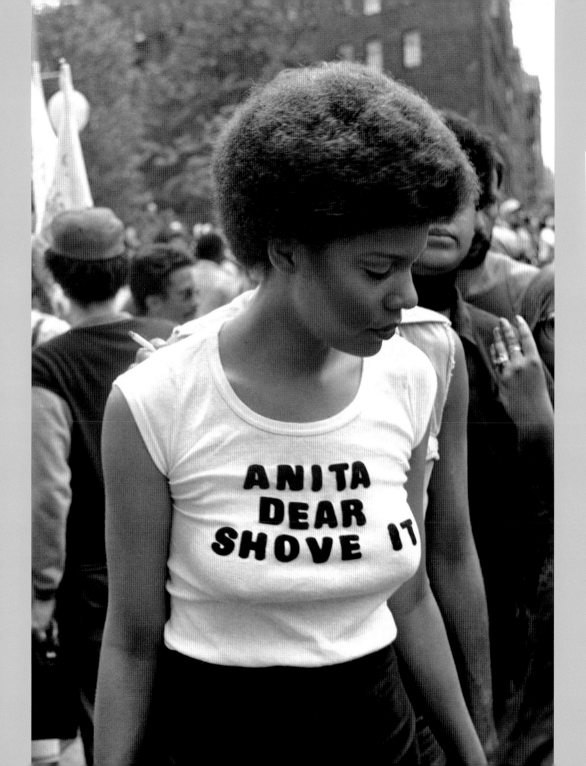

49

The lonely standard
bearer,
distracted from love by cigarette
yen.

Aren't you hot in your angry leather?
Any you guys want to get beat up under the pier
& come on my shoe?

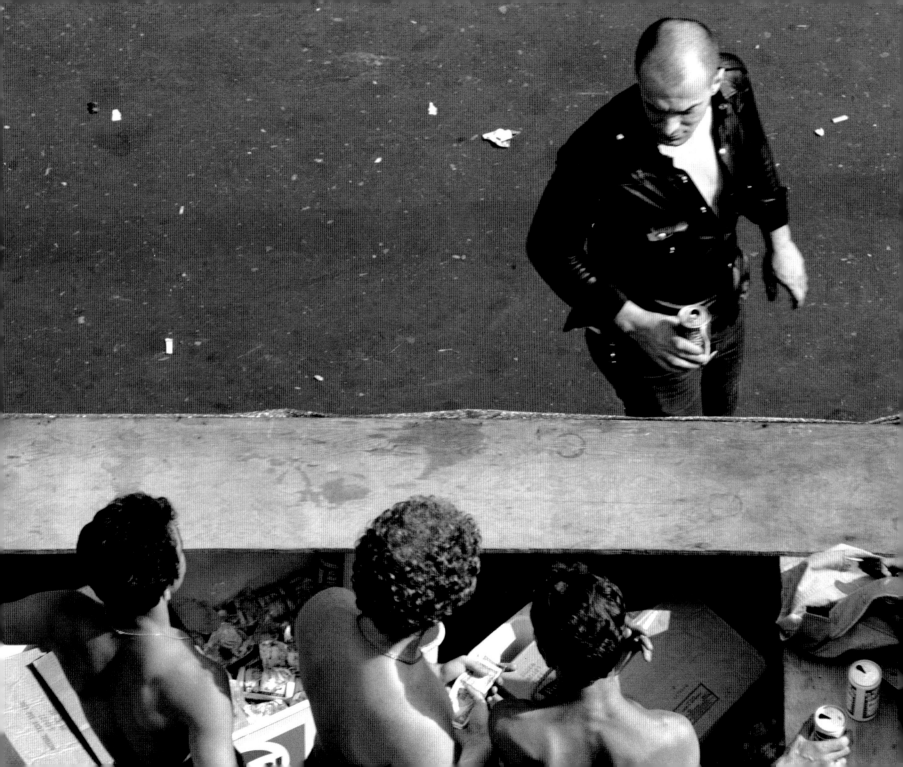

His hair on his belly & my bulge
at the crotch! And the sequins & wigs!
And the traffic lights! And black
Hamlet smiling to himself!

52

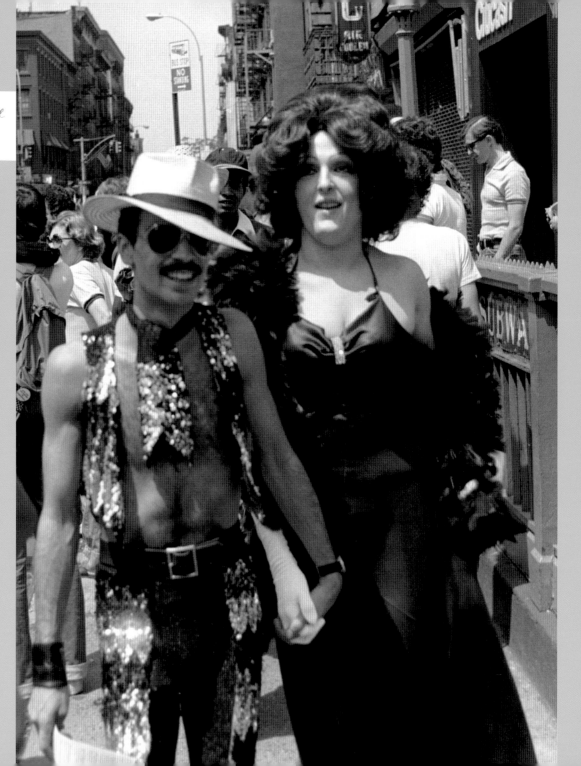

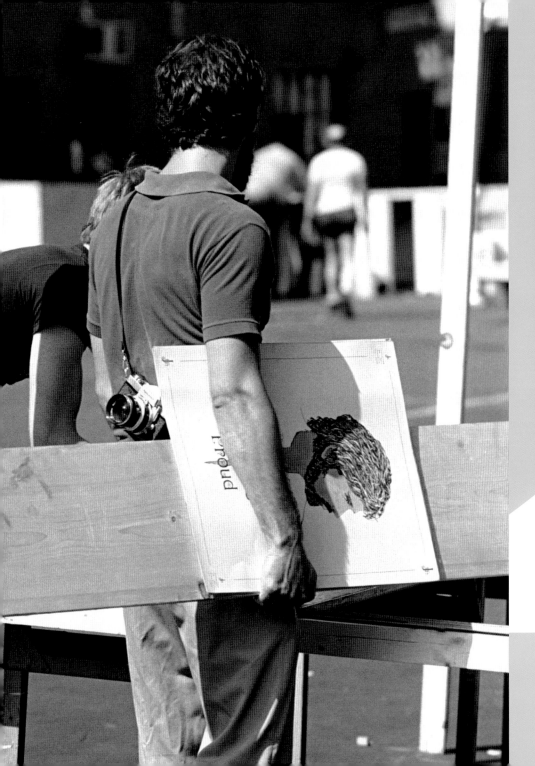

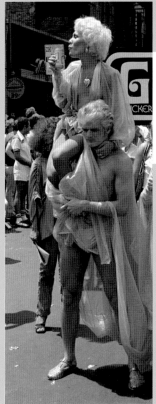

Flash Gordon +
his wife drinking
gay beer.

Flash Gordon &
his wife drinking
gay beer.

53

His hair's got the same light
as the hair-picture head under
his arm. The old ghost in the
back's walking away in shorts.

His hair's got the same light
as the hair-picture head under
his arm. The old ghost in the
back's walking away in shorts.

Good tight dress, totally olive oil lady from midtown, but the top's a baseball capped ruffian whistling at the whores.

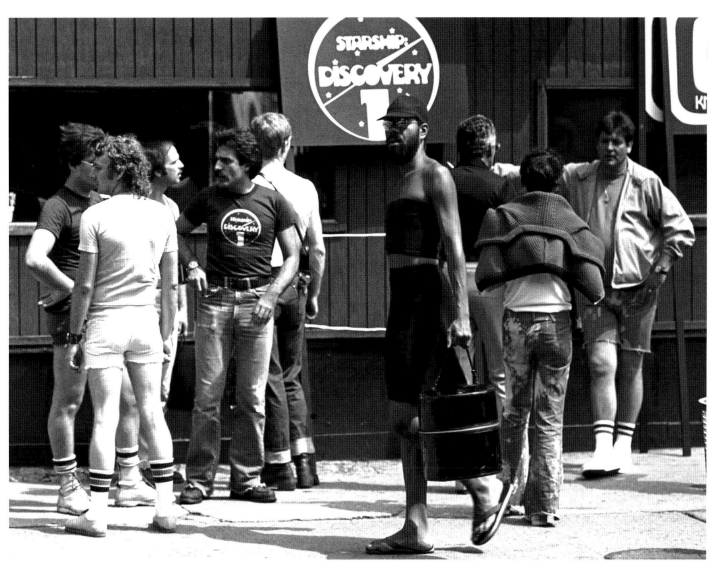

Well I'll carry my wig box
(tee) find my hero, then I'll put on
a new skull.

Well I'll carry my wig box
'til I find my hero, then I'll put on
a new skull.

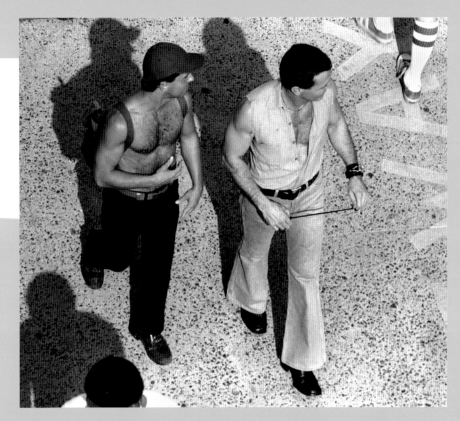

*Casting a shadow on the speckled walk
two philosophers observe the sneakers of old
Rudolph Valentino
and decide to look in at Byzantium.*

57

See anyone there you'd like to have VD with?

58

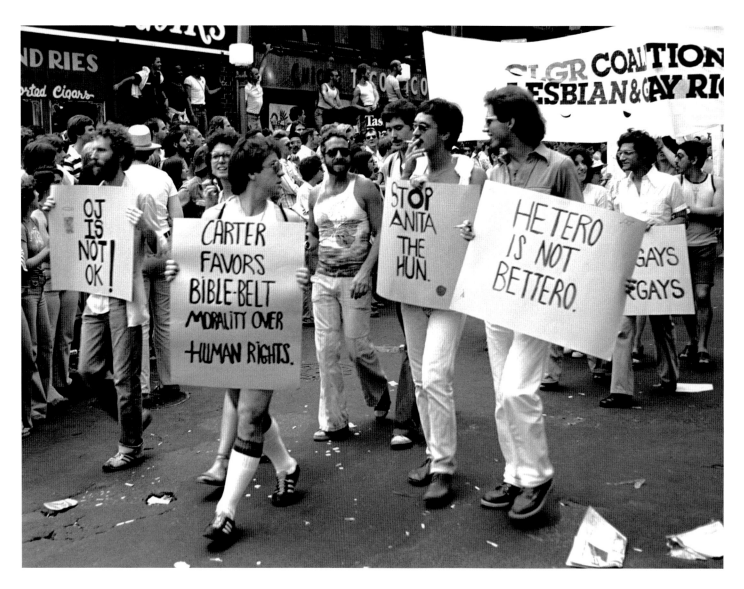

Those guys *on the wall watching,* *are they gay or just having a good time? Those black dudes,* *the one with the cap, smiling.*

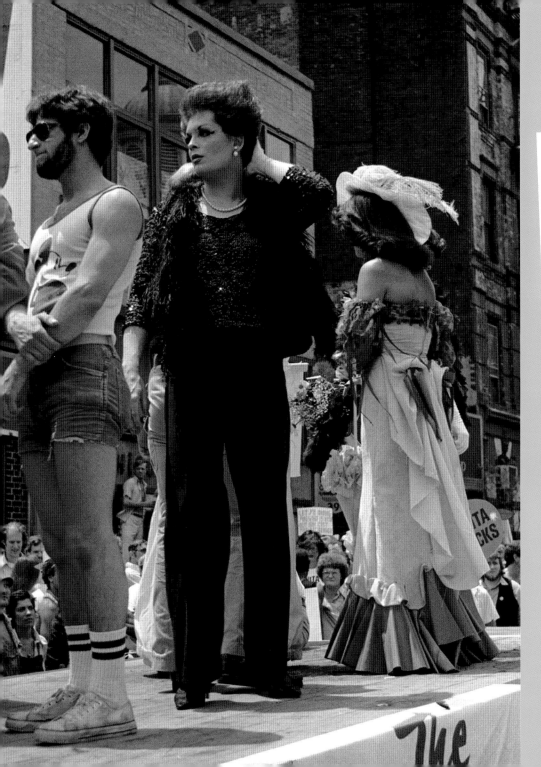

Judy got older & stood on
a flatbed truck fixing
her hair alone in the crowd, looking
at a traffic cop's crotch—or is
it the latest Cleopatra?

59

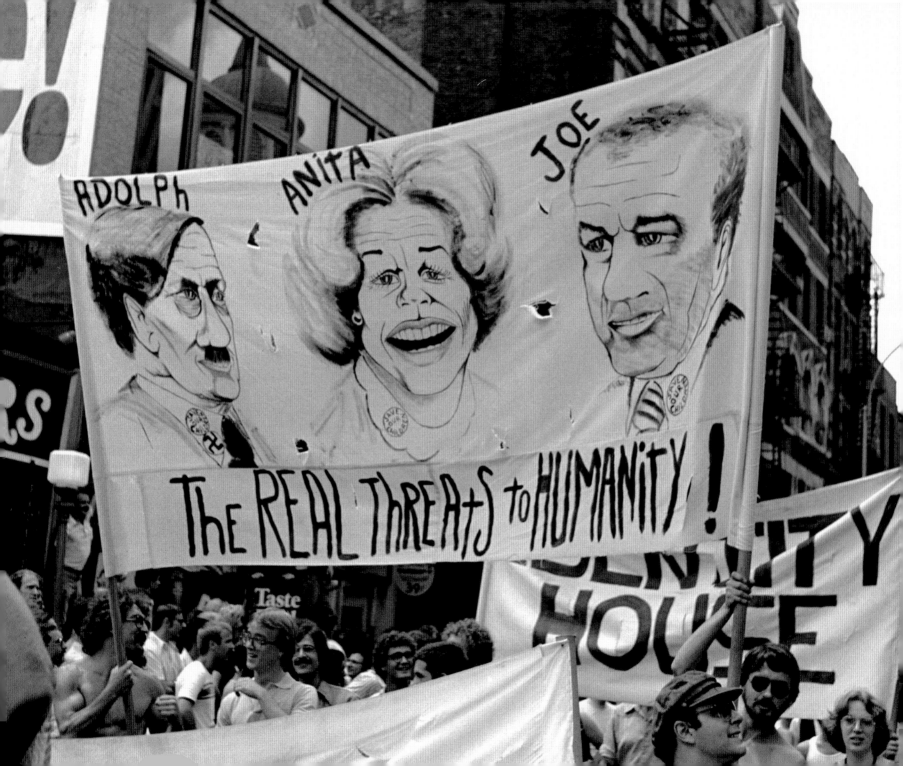

*What a pleasant conversation they're having under Hitler's head,
guy with handsome bicep chest, holding the banner aloft
lightly, and the eyeglassed smiling inquirer.*

*Shoes sox watches white pants tea shirts &
balloons.*

61

Drinking, smoking, with covered
behinds in the sunlight, aprons &
vests, the shadow of Hiawatha
stretched out on the ground.

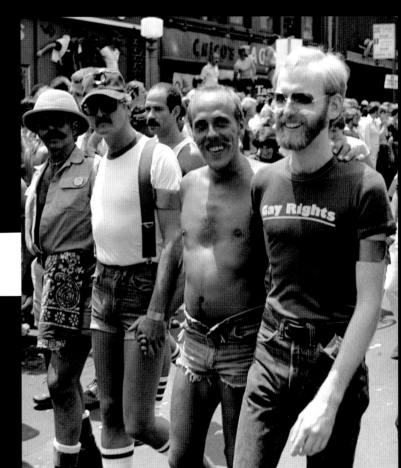

You mean all that hair & teeth
is gay?

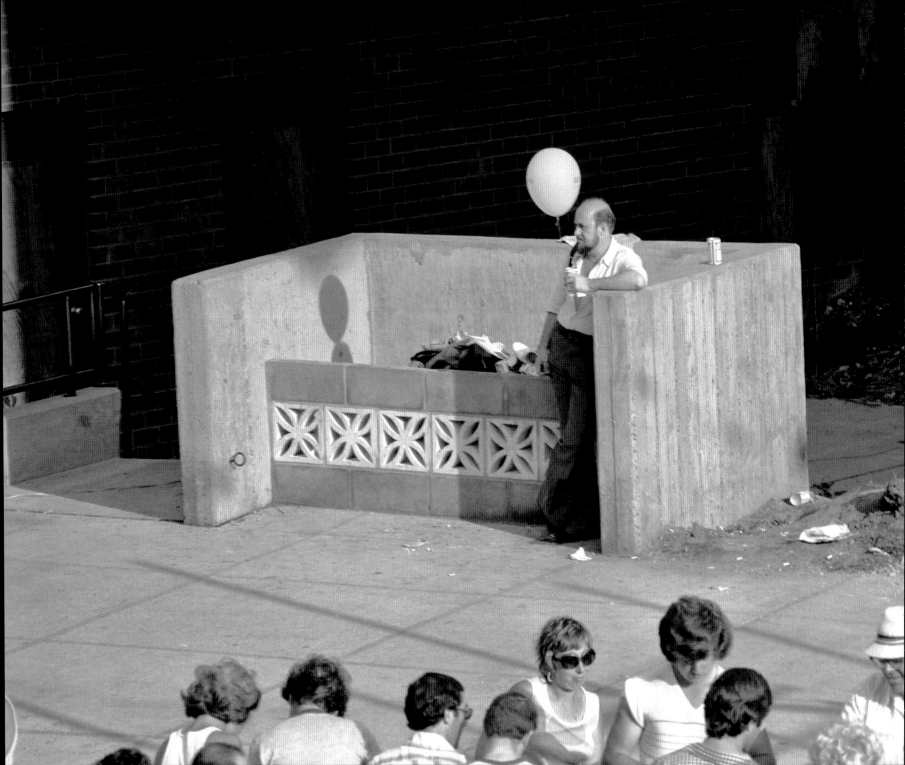

Don't they look like tender kids,
the mustached leather troopers?

Don't they look like tender kids,
the mustached leather troopers?

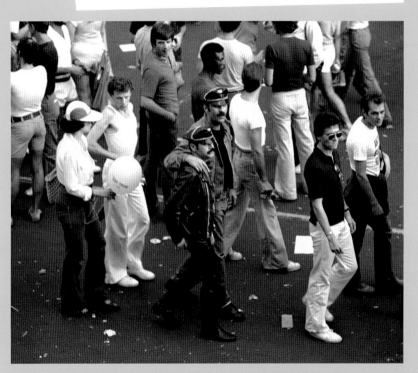

65

Alone in the garbage dump with a beercan + a baloon,
middleaged bald cend thoughtful, shirt unbuttoned to
the stomach, waiting for Arthur Rimbaud.

Alone in the garbage dump with a beer can & a balloon,
middleaged bald and thoughtful, shirt unbuttoned to
the stomach, waiting for Arthur Rimbaud.

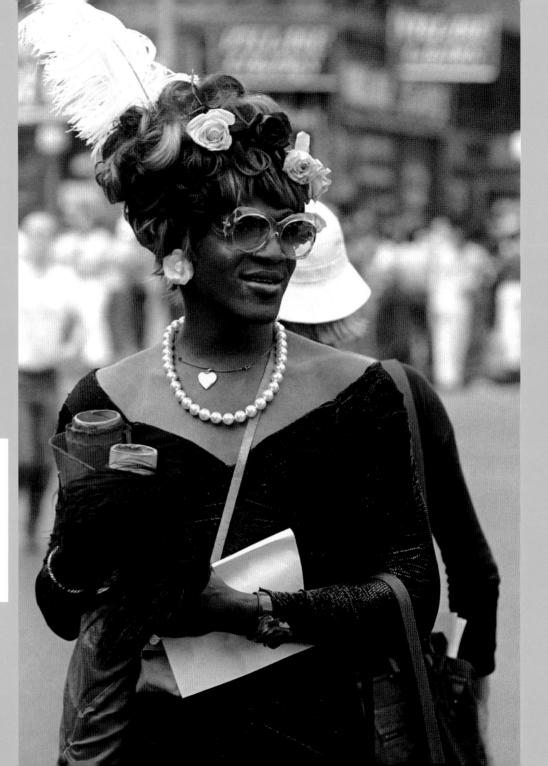

If I keep dressing up like this I'll save the world from Nuclear Apocalypse. But will anyone love me for it? I'll save the world anyway. I know what looks good

If I keep dressing up like this
I'll save the world from
nuclear apocalypse. But will anyone
love me for it? I'll save the world
anyway. I know what looks good.

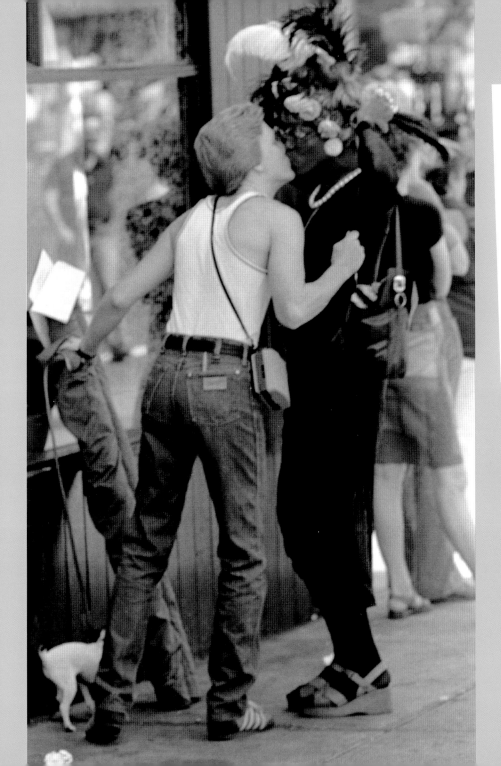

I deserve a cute
boy's kiss for this
truthful hat. And he's
so sensitive, look at that
tiny white dog!

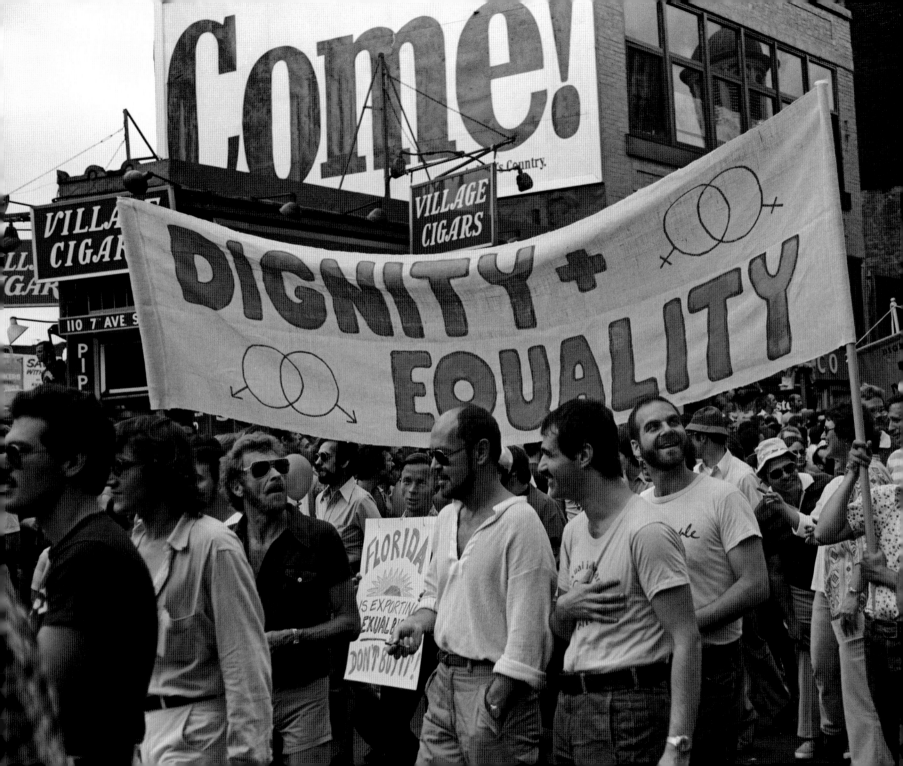

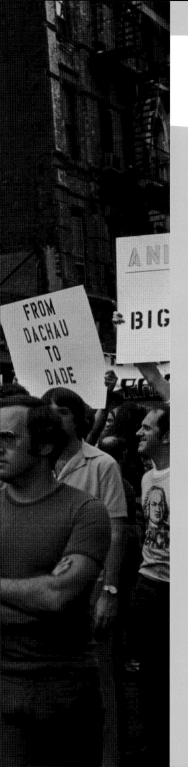

Come all over the sky, look up!

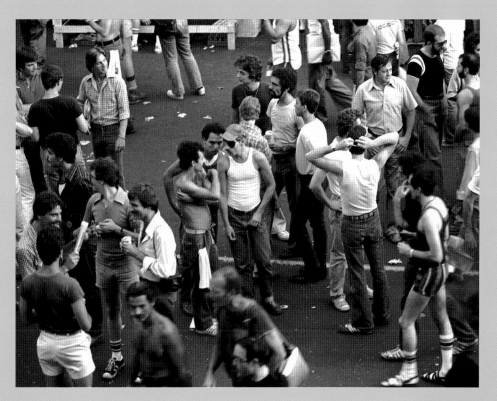

Two guys with chains round their neck look at each other for the first time across the huge six-foot distance.

Gay guys sit talk listen smoke pick their teeth like anyone else.

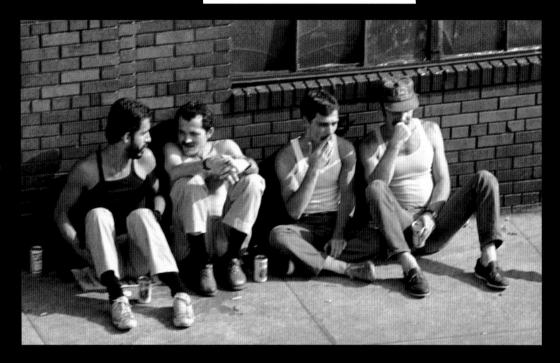

70

Gazing off in the distance. Gee he's sweet.

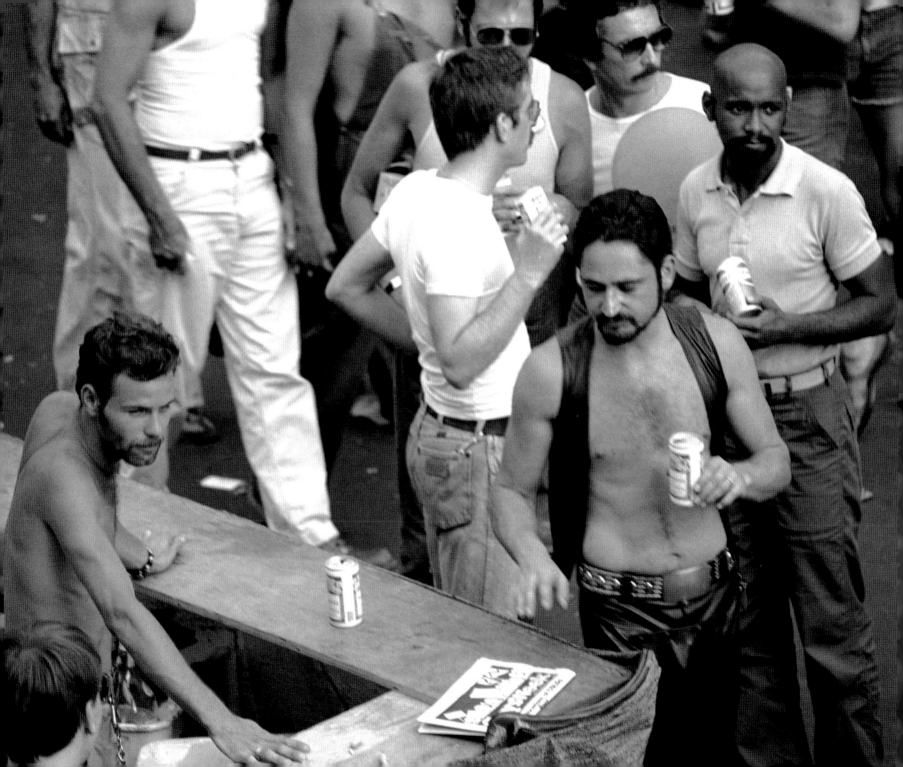

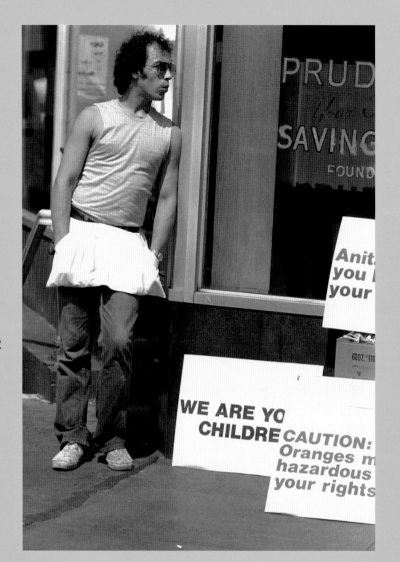

*A spy from the moon
with his motorcycle wired
up as erotic transmitter to 7th Heaven
(the beams bounce off his skull into
outer space)*

A Spy from the moon

with his motorcycle wired
 as erotic
up as sent transmitter to 7th Heaven

(the Beams bounce off his skull into

outerspace)

Insouciant Prudence whistling

away his muscular hours.

*Insouciant prudence whistling
away his muscular hours.*

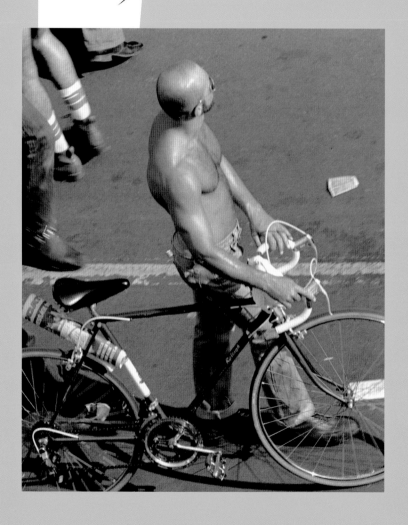

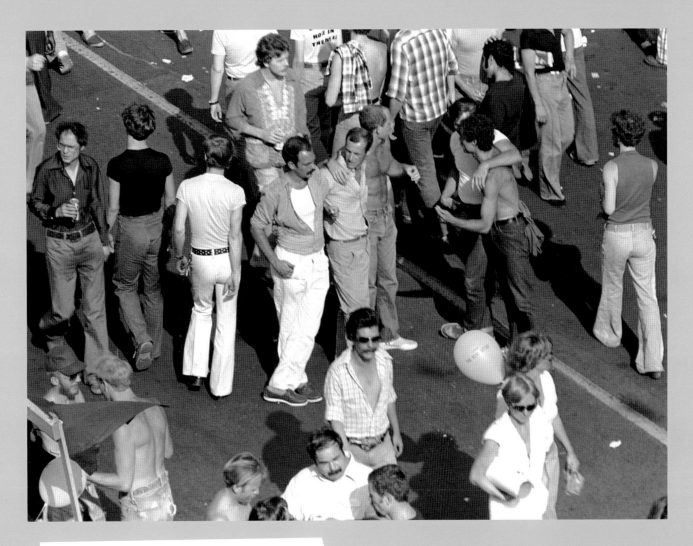

Guys at the Union
each other
lean on eacholter like this,
as ~~Whit~~ as whitman Noticed

Guys at the union
lean on each other like this,
as Whitman noticed.

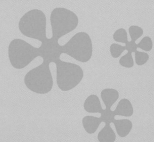

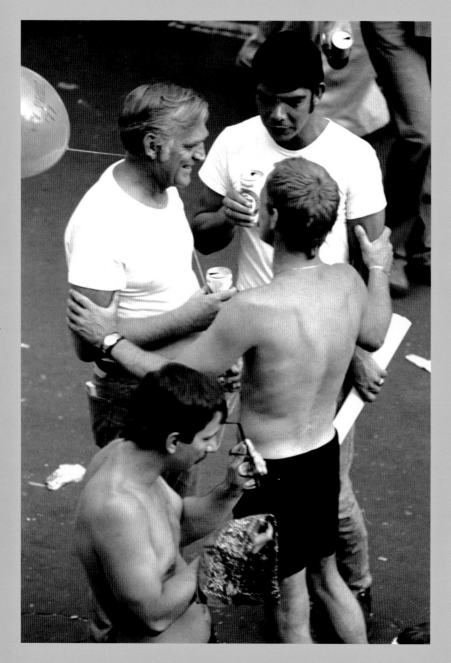

74

*Now you realize he'll just
love you if you get him the
job you were talking about,
and he's reliable . . . that
man of distinction look . . .*

*The oldest lovers in the universe
raising their hands in applause
& benediction.*

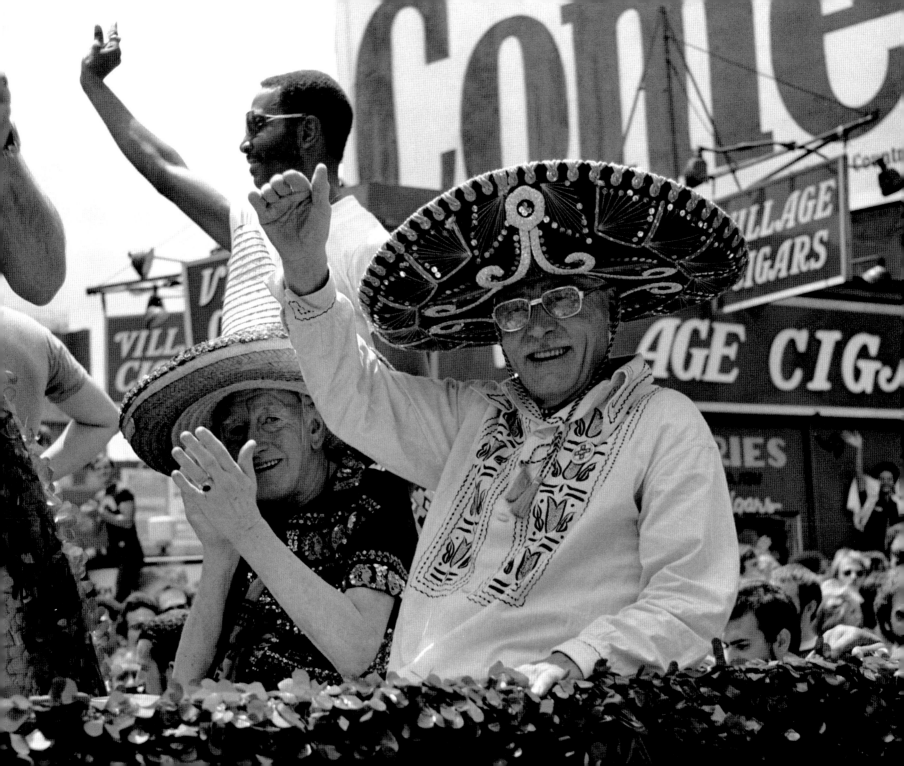

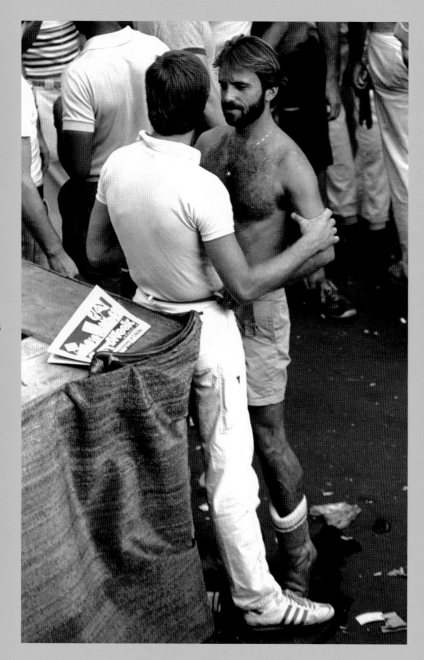

76

You don't deserve it but I'll give it to you anyway.

Hey pay attention, remember what we decided?

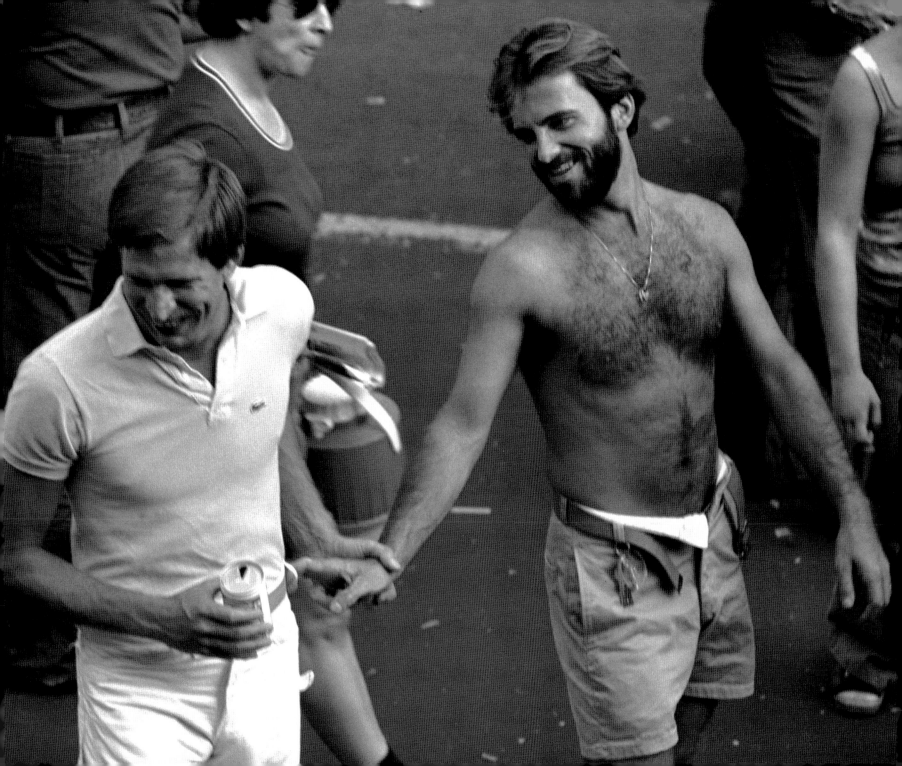

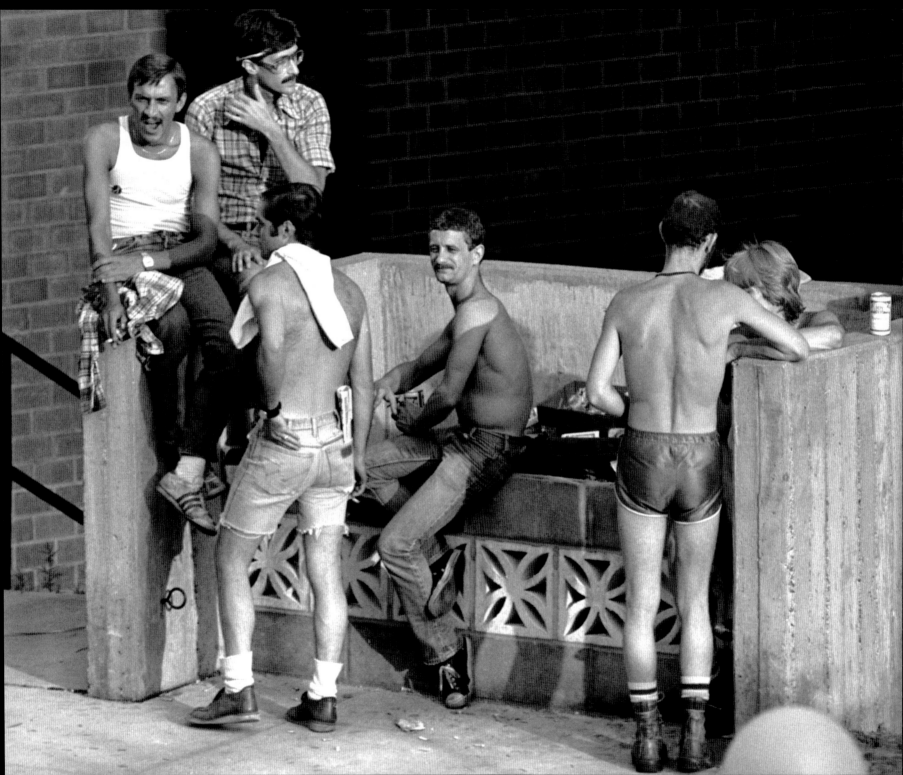

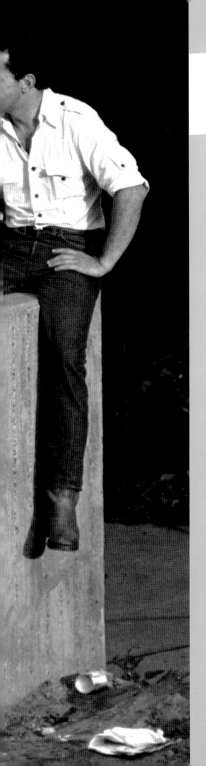

Beauties hanging around the
stone garbage dump.

*Beauties hanging around the
stone garbage dump.*

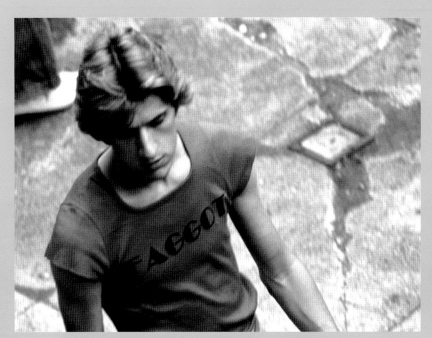

79

The most beautiful faggot daydreams

of his cousin's lips.

*The most beautiful faggot daydreams
of his cousin's lips.*

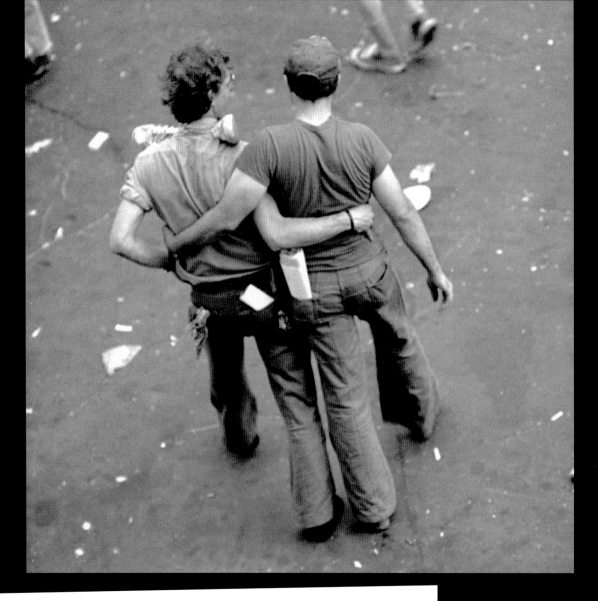

Let's stagger home & unload a ship.

Let's stagger home & unload

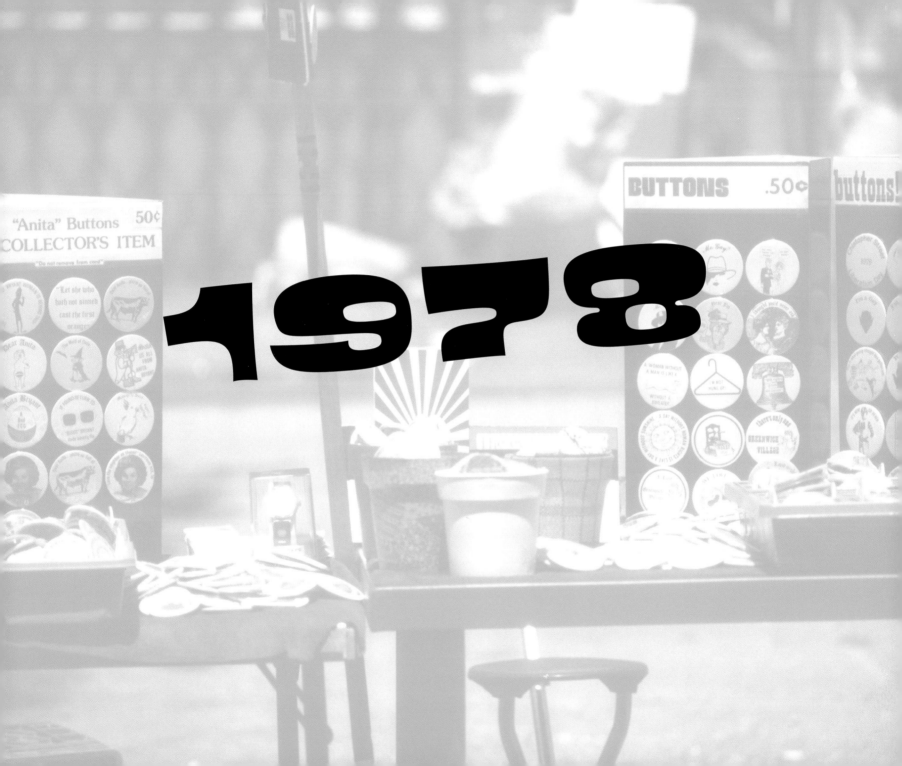

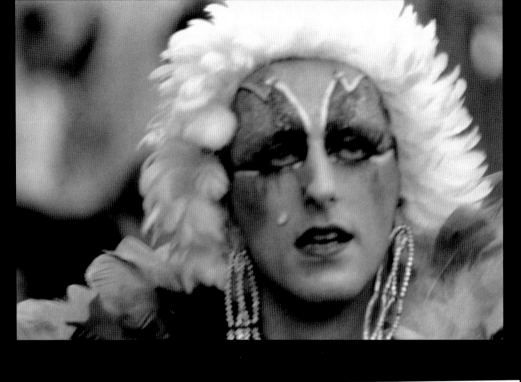

" I know that my redeemer liveth."

Whose Bold Kiss? Whose
hairy youngish hand onto time machine?

Whose bold kiss? Whose
hairy youngish hand on the time machine?

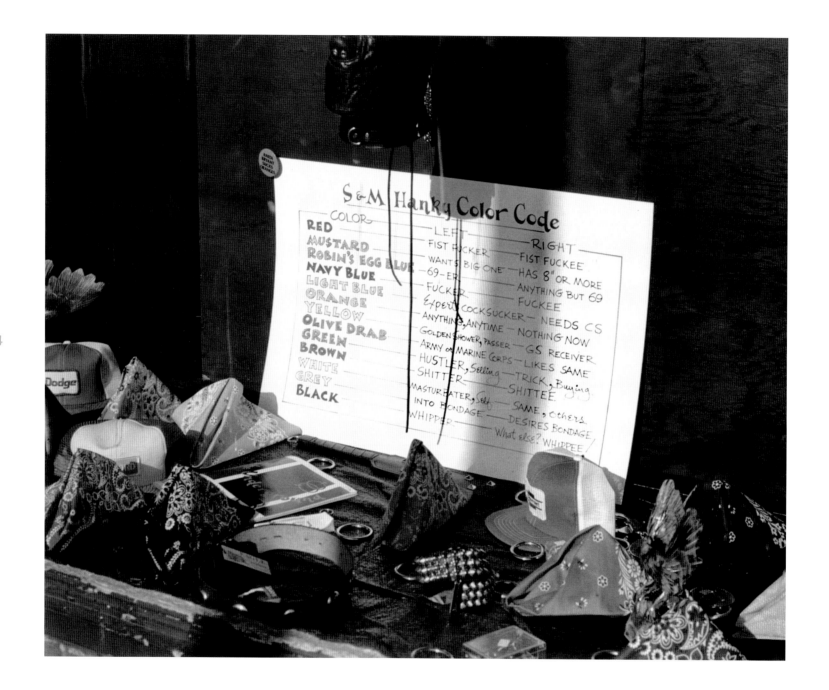

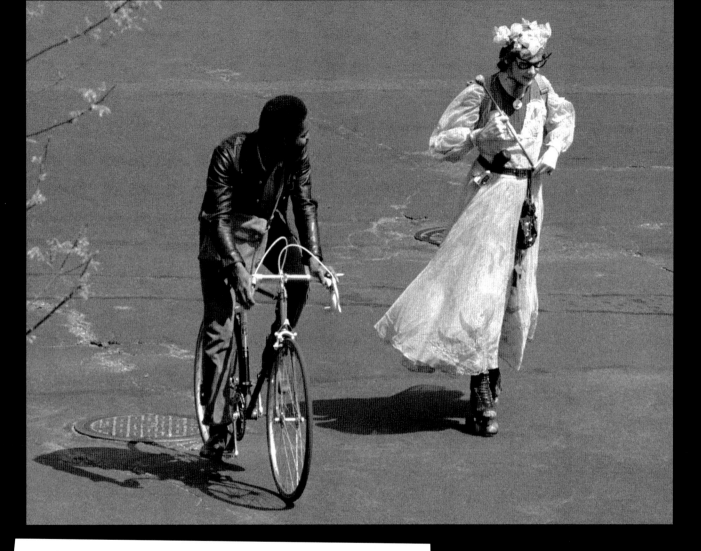

Miss Rollerina, queen of late 70's disco world universe drama, observed by a (gay??) black man on the asphalt.

Miss Rollerina, queen of late 70s disco world universe drama, observed by a (gay??) black man on the asphalt.

That ~~an umbrella~~ pyramid-shadow
flooding out of her right eye's ~~an~~
an umbrella.

That pyramid-shadow
flooding out of her right eye's
an umbrella.

86

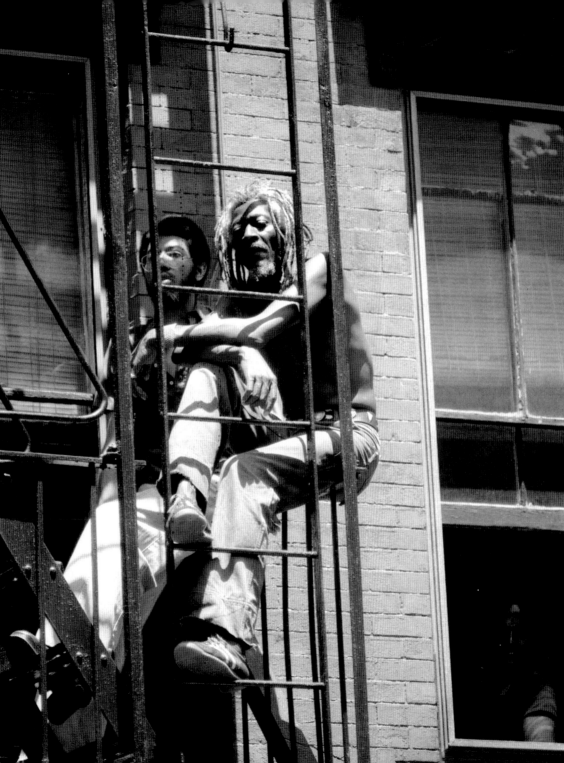

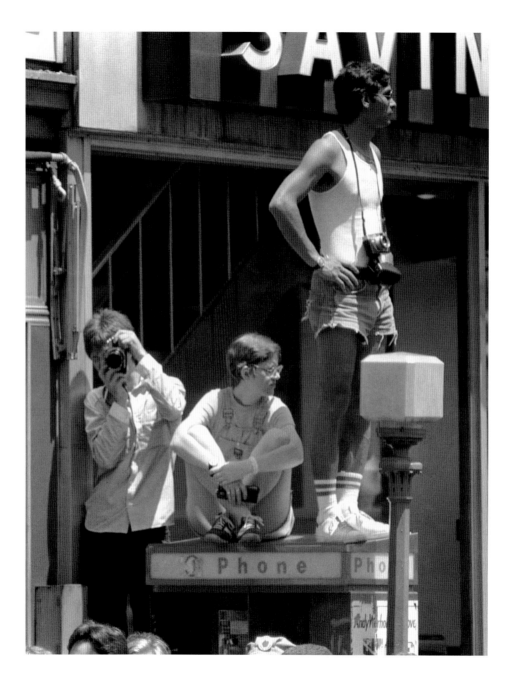

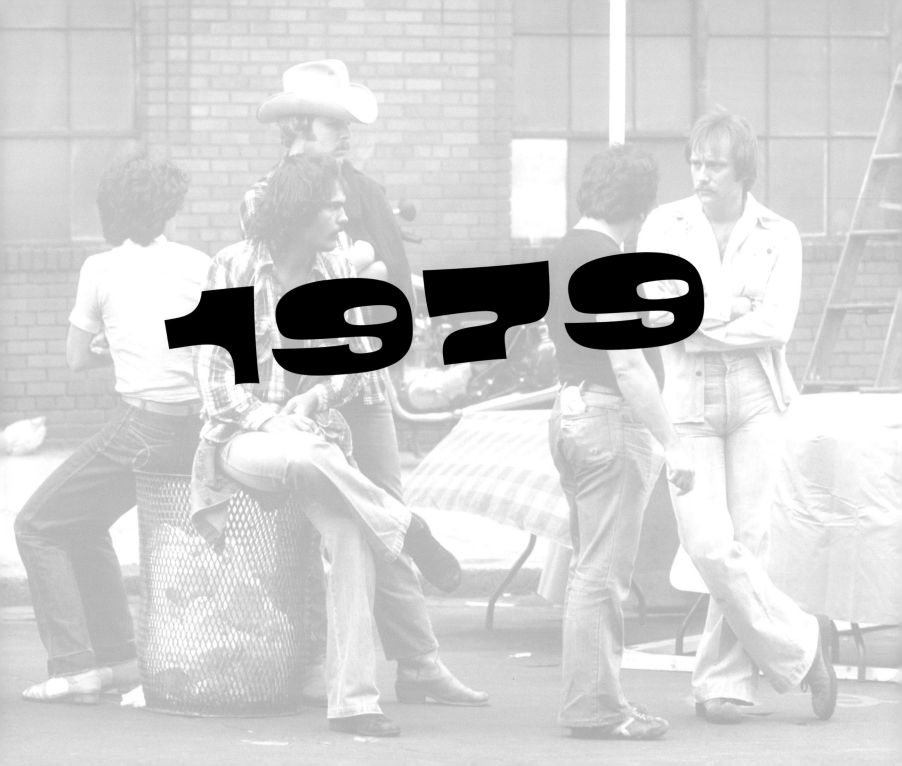

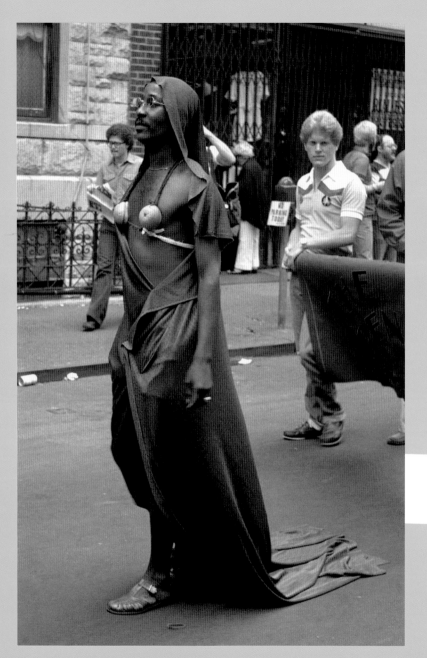

90

Does Cosa Nostra still own
all the Gay Bars in N.Y.?
Or is that guy queer too, behind the
counter.

Nubian Mama

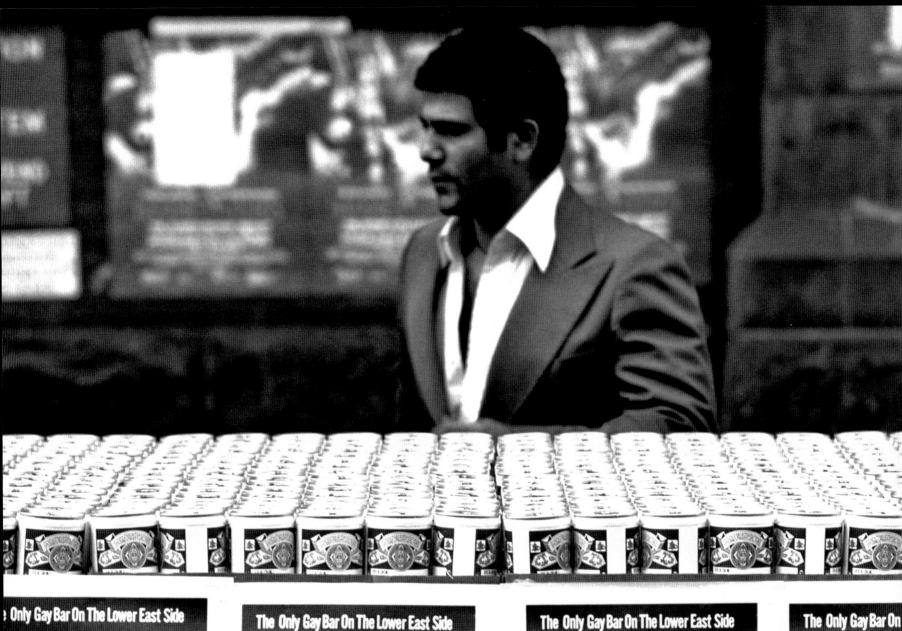

The Only Gay Bar On The Lower East Side

THE BAR

●CRUISE BAR●POOL TABLE●GAMES●
68 Second Ave. at E. 4th St. - 674-9714

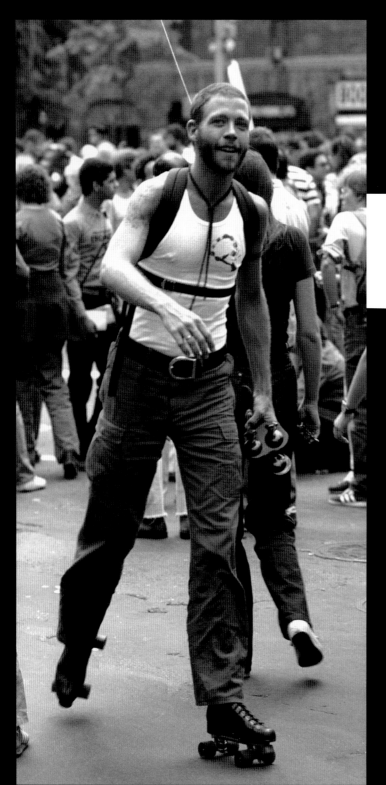

*Young & handsome, with
my antennae and my
shoulder got burned for wearing
a pink triangle at Buchenwald.*

*Tired, handsome, a little drunk, standing around in
Manhattan, what'll we do next?*

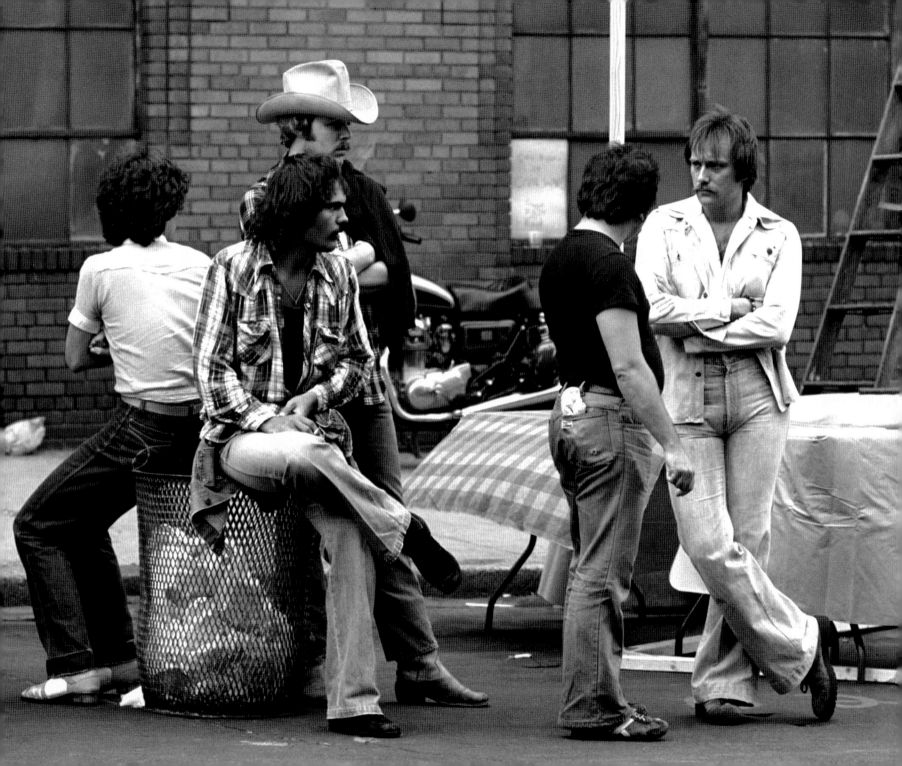

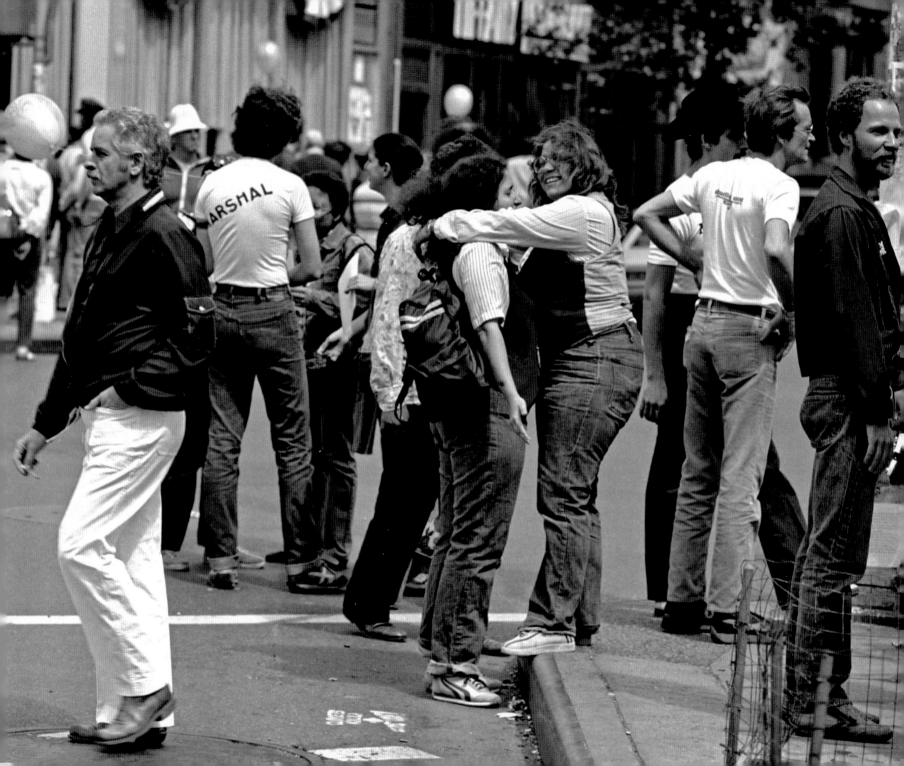

*I'm so happy! I can display my
big fat ass on the curbstones of heaven!*

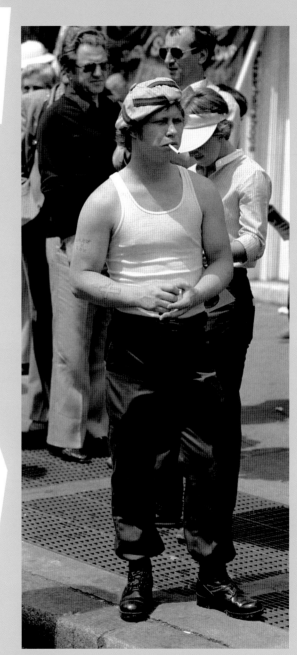

*Catholic boy with
nicotine addiction gazing
into the distant Viet Nam
jungles, mouth drawn
downsides anxious for
tobaccosmoke.*

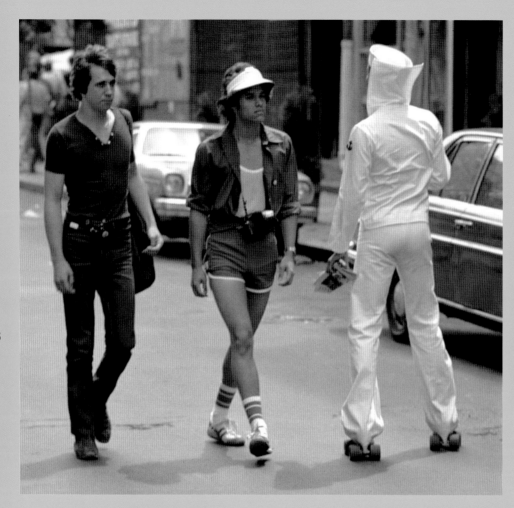

96

Well whaddya think honey?
Yes I play ball.
Am I a lesbian mother or someone
else from Bronx?
He better not pick up that sailor or I'll cry.

Well whaddya think honey?
Yes I play ball.
Am I a lesbian mother or someone
else from Bronx?
He better not pick up that sailor or I'll cry.

The wind of love whipped the
collar up round my head, but I
got a good ass myself.

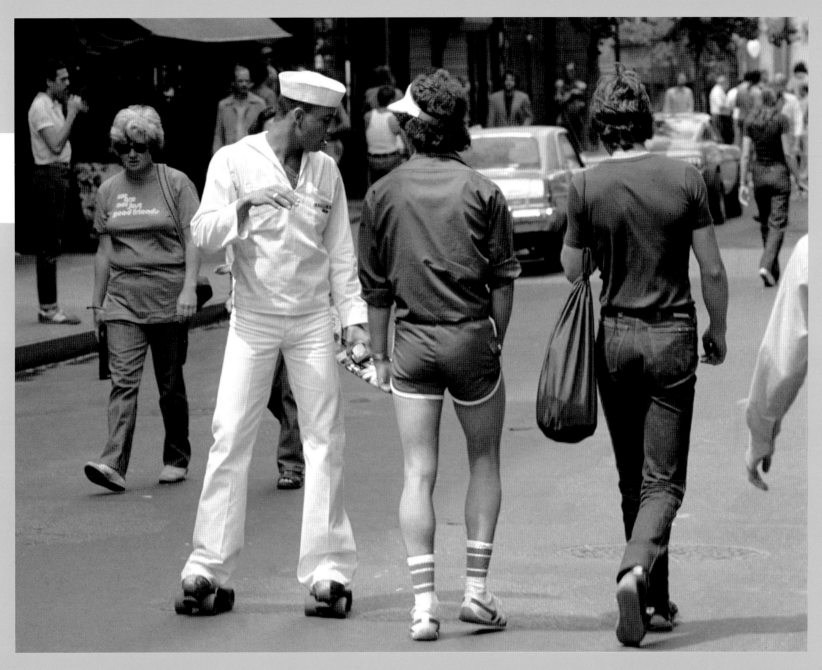

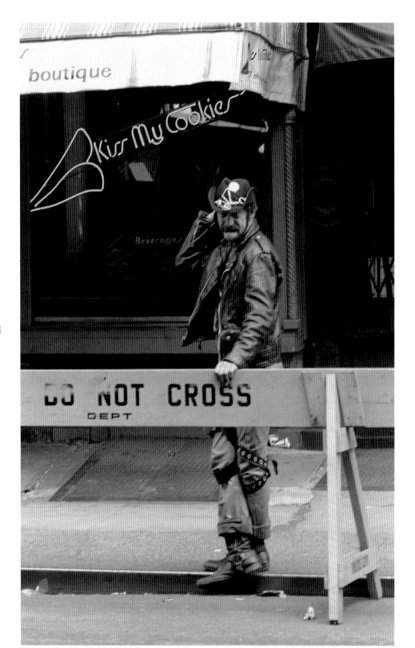

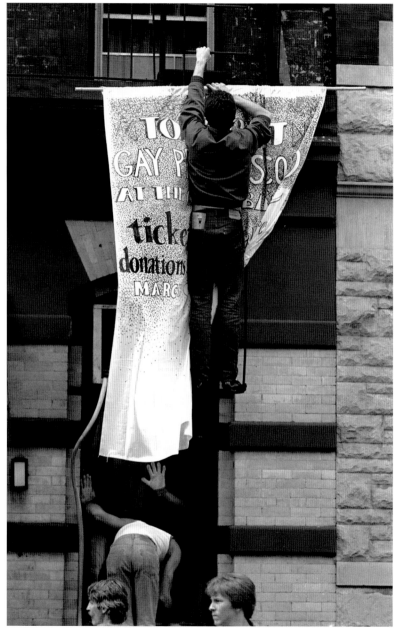

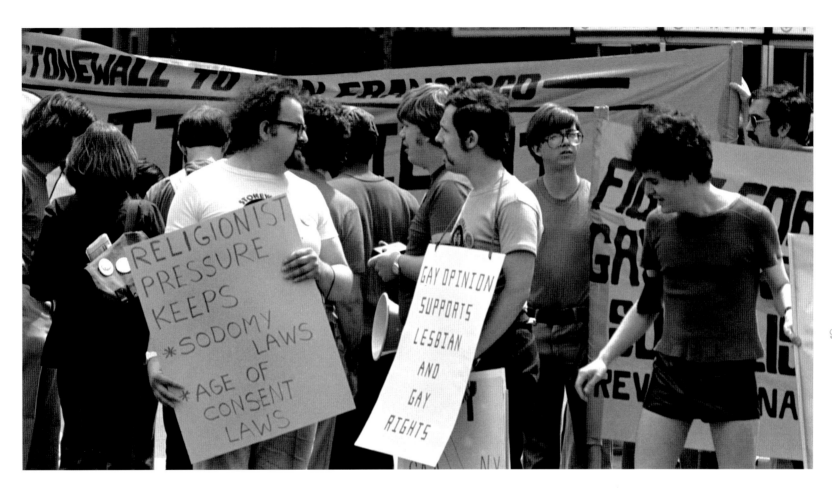

We have a right to be wounded!

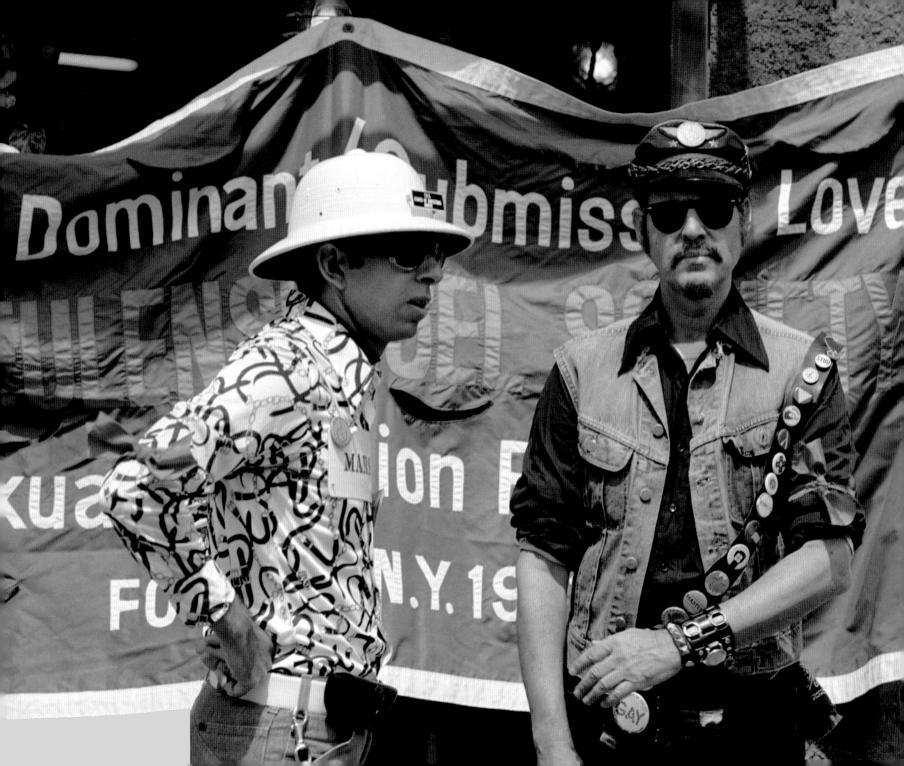

Awright men straight Cops! You want to have a basketball contest?

Awright you straight
cops! You want to have
a basketball contest?

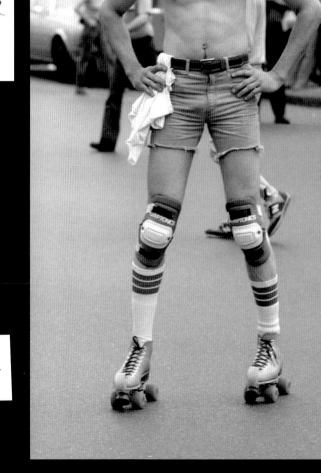

101

I Allen Ginsberg likes to be spanked myself.

I, Allen Ginsberg, like to be spanked myself.

That heroic blond snubnosed kid
in the backroend happeas to be Homer +
owrs 1000 ships of state-

That heroic blond snubnosed kid
in the background happens to be Homer &
owns 1000 ships of state.

102

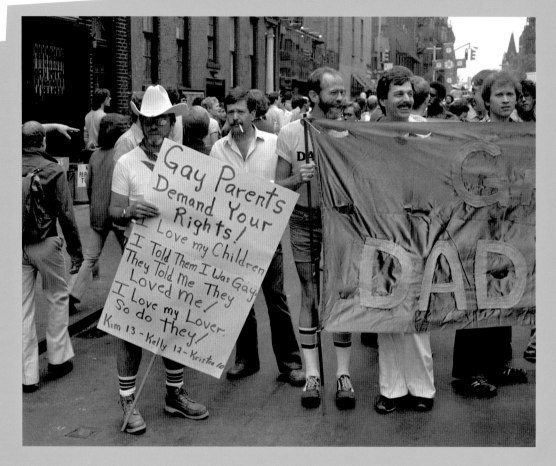

The Guy in the right looks like my daddy when
he was young (and alive).

The guy in the right looks like my dad when
he was young (and alive).

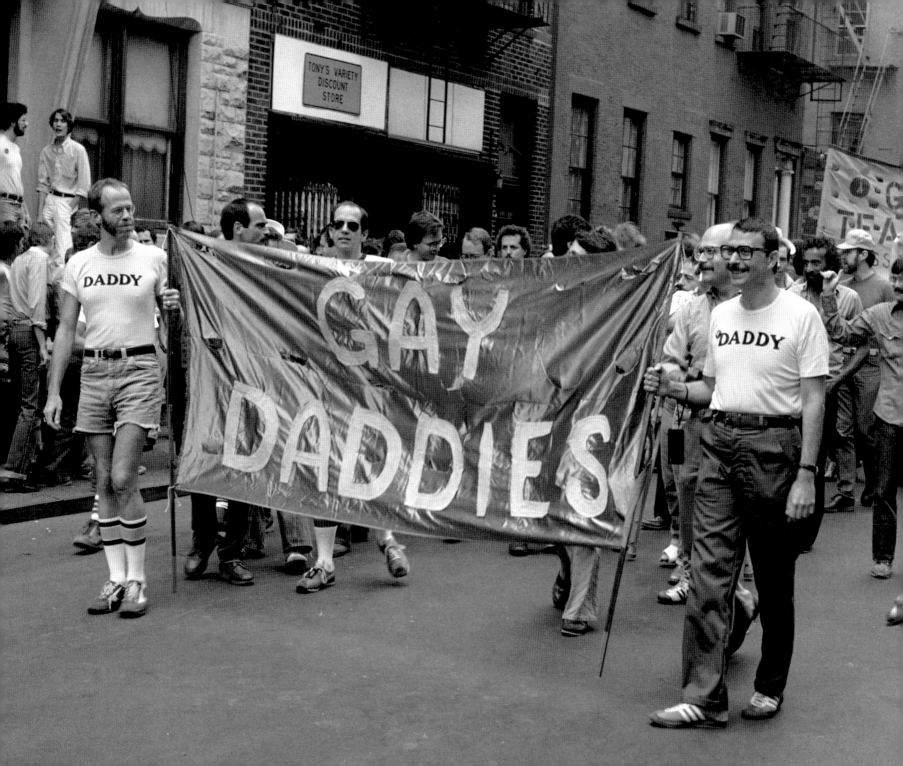

That thin guy bent over signing, is
his face cute as his thin angel hair?

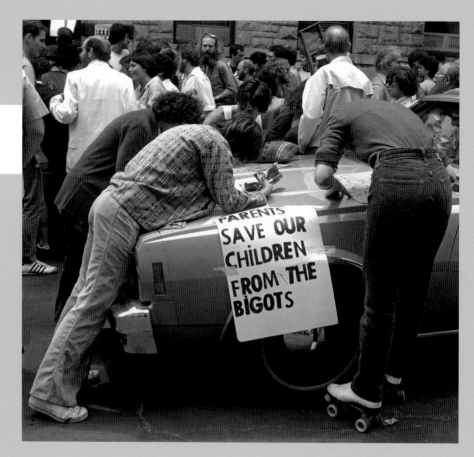

104

It's true! Jehovah's like N.K.V.D. "Don't eat that
knowledge apple," said the voice of stupid Satan-God,
as interpreted by Blake.

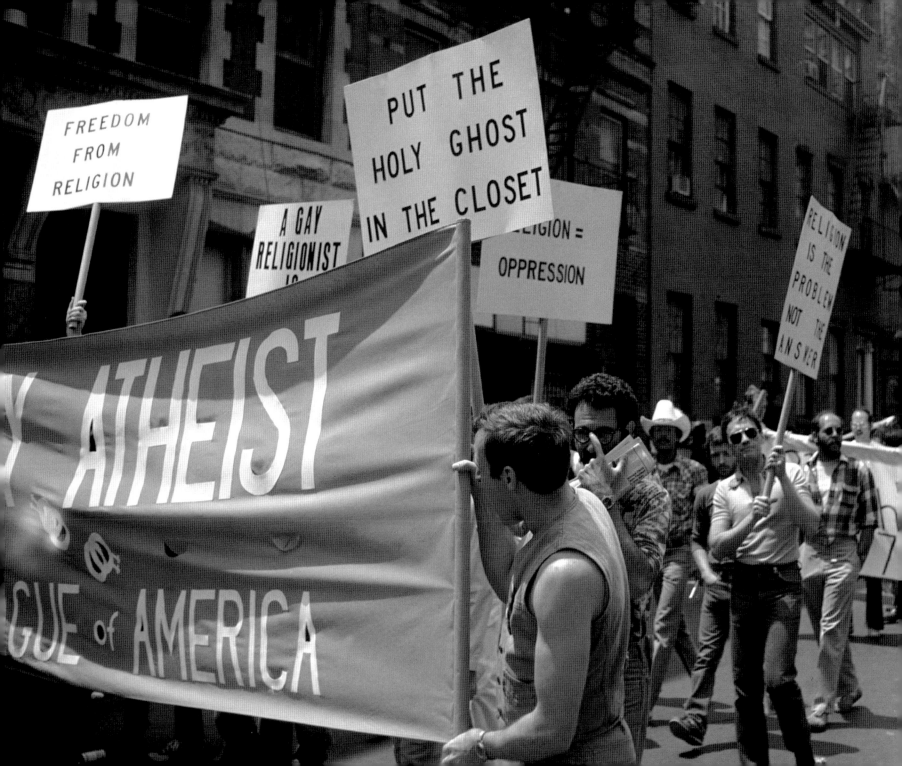

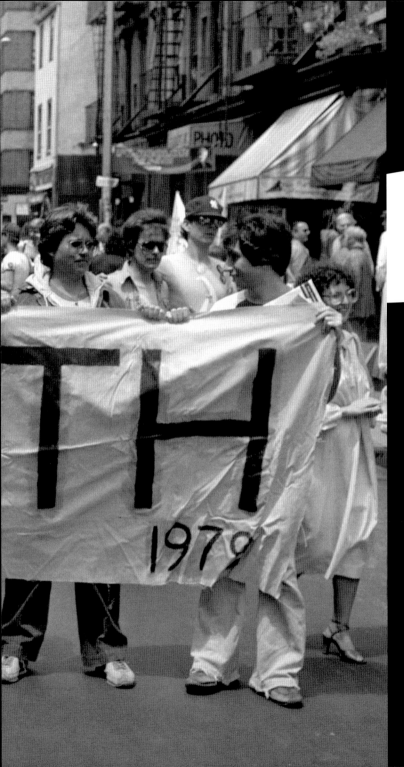

brown what idealism!—
Black white boy girl ~~puerto rico~~ ~~banner bearers~~
~~what idealism to wear their heads on~~ wearing their
heads on a banner for nothing but love

Black white brown boy girl what idealism!—
wearing their
hearts on a banner for nothing but love.

107

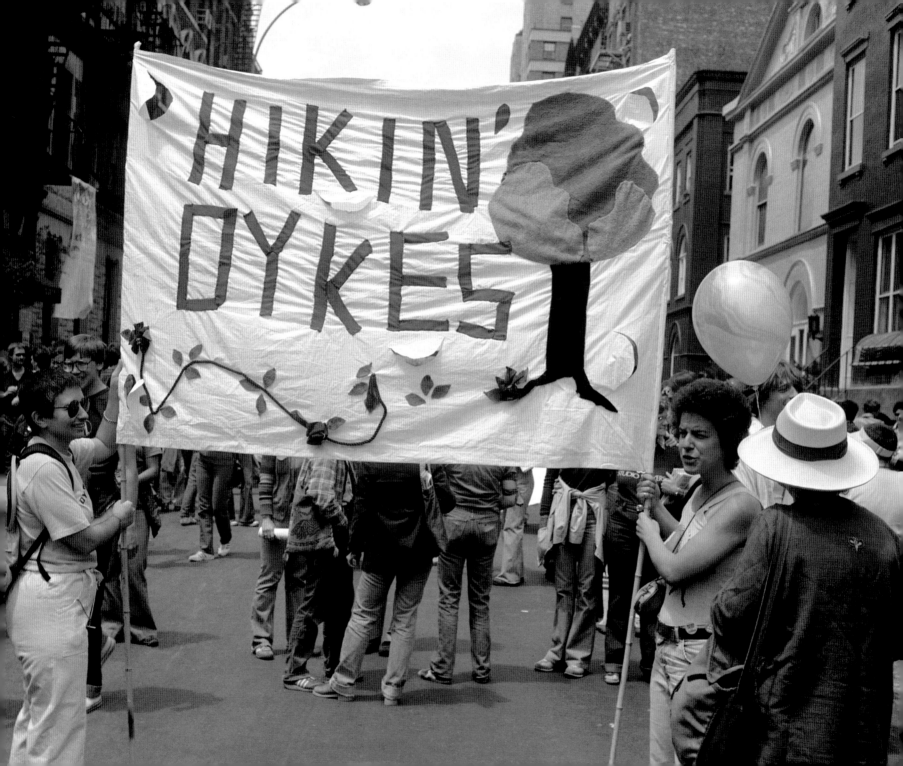

They did the whole Appalachian Trail in
2 seconds flat.

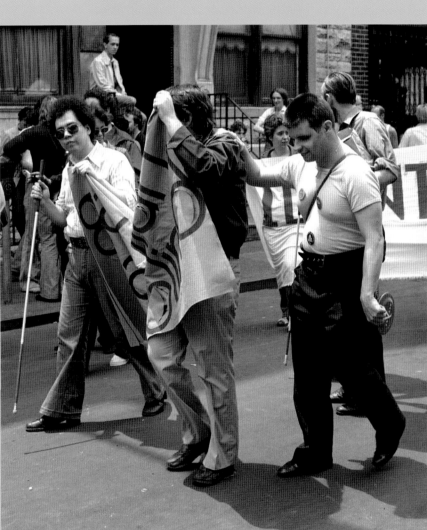

109

The blind have many loves.

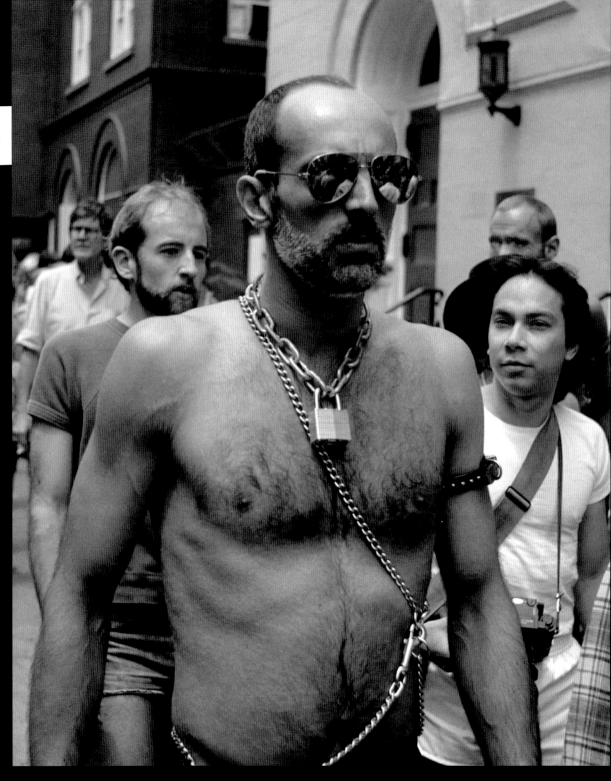

I can take it in the tit.

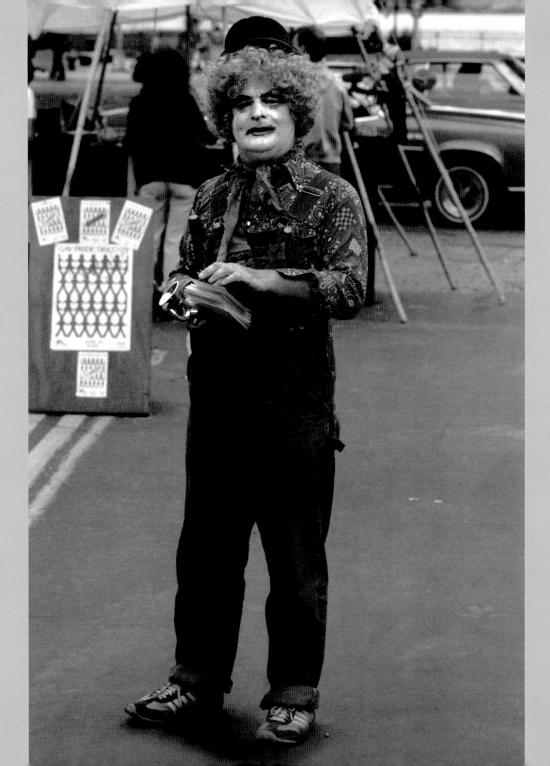

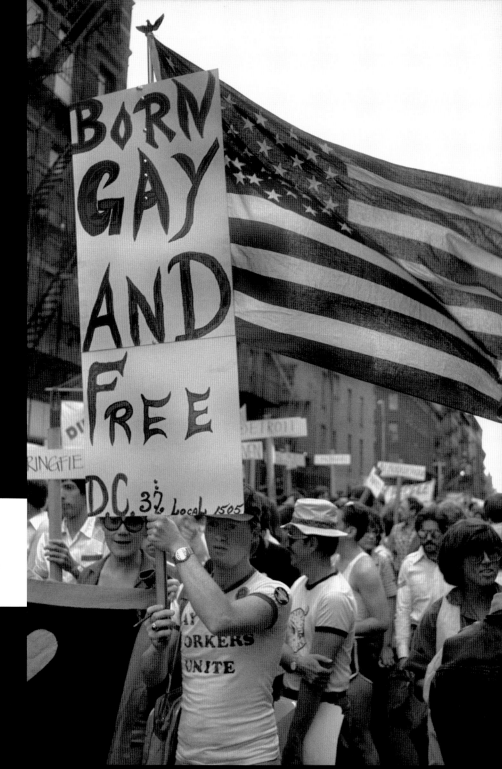

What a pretty worker! Brave
handsome Courageous & ~~true~~
true.

*What a pretty worker! Brave,
handsome, courageous, & true.*

O Lord! Dios! I got
a giant pecker in my
brain!

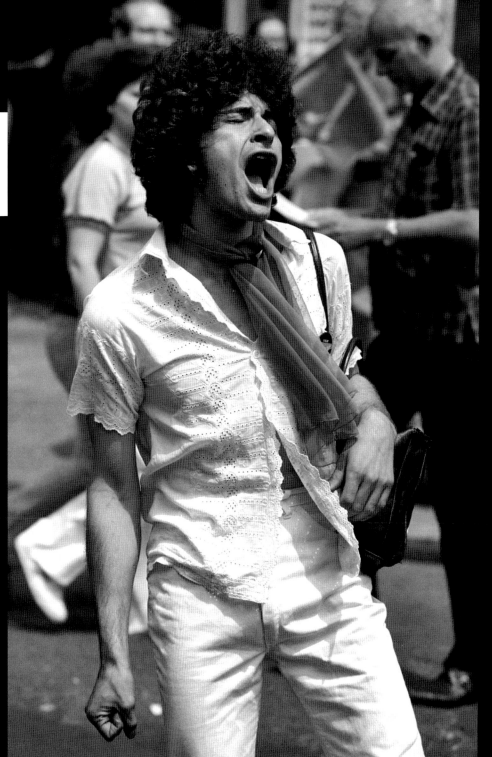

Highstepping in his shell beads & jockstrap
hand on the transparent flagpole
Teeth white as a fairy's overalls.

Highstepping in his shell beads & jockstrap,
hand on the transparent flagpole.
Teeth white as a fairy's overalls.

114

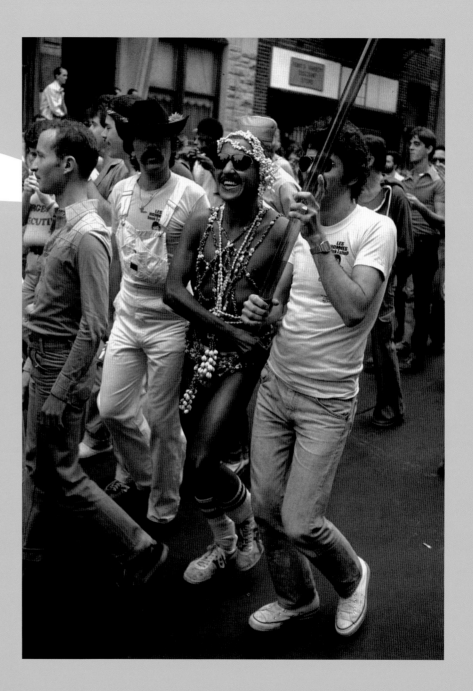

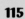

Do you think the City Planning
Commission calculated
that junkies would burn
down East 3'd St.

Do you think the City Planning
Commission calculated
that junkies would burn
down East 3rd Street?

115

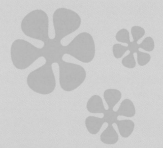

Actually she's a
Floating TruthCloud
with no identity.

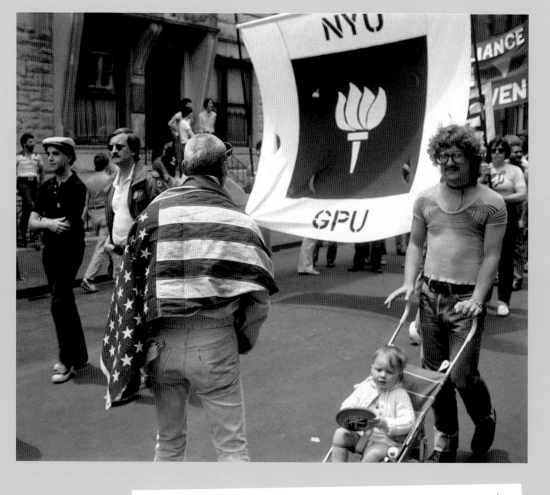

Yessir that's my baby with his
flying saucer. And that's my flag on my
old back.

Actually she's a
floating truth cloud
with no identity.

Yessir that's my baby with his
flying saucer. And that's my flag on my
old back.

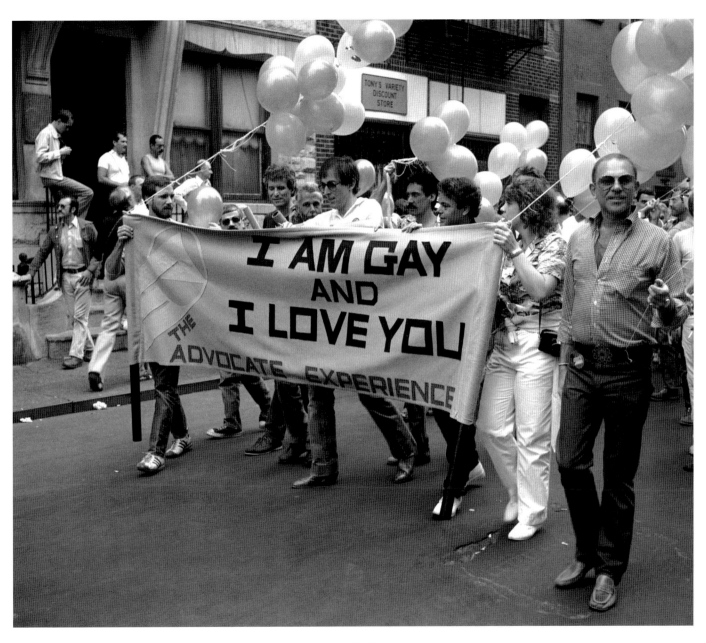

117

I wonder if Ronald Reagan knew how much he was loved once upon a time.

I wonder if Ronald Reagan knew how much he was loved once upon a time.

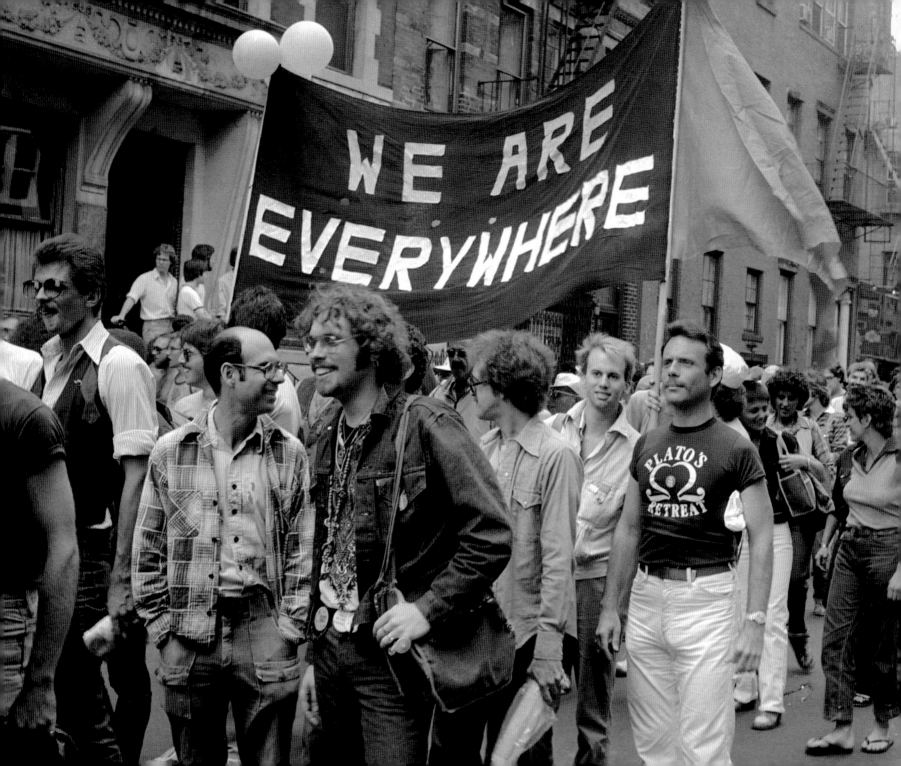

Clark Gable & Nero on a date,
smiling for 1920s Hollywood photogs.

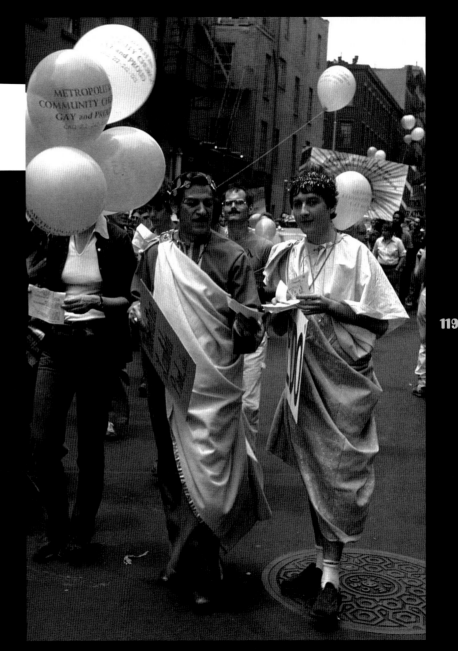

We all look pretty normal,
boy next door, handsome punk,
ad man's delight, Daughters of the
American Revolution.

Harvey Milk died for your sins.

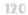

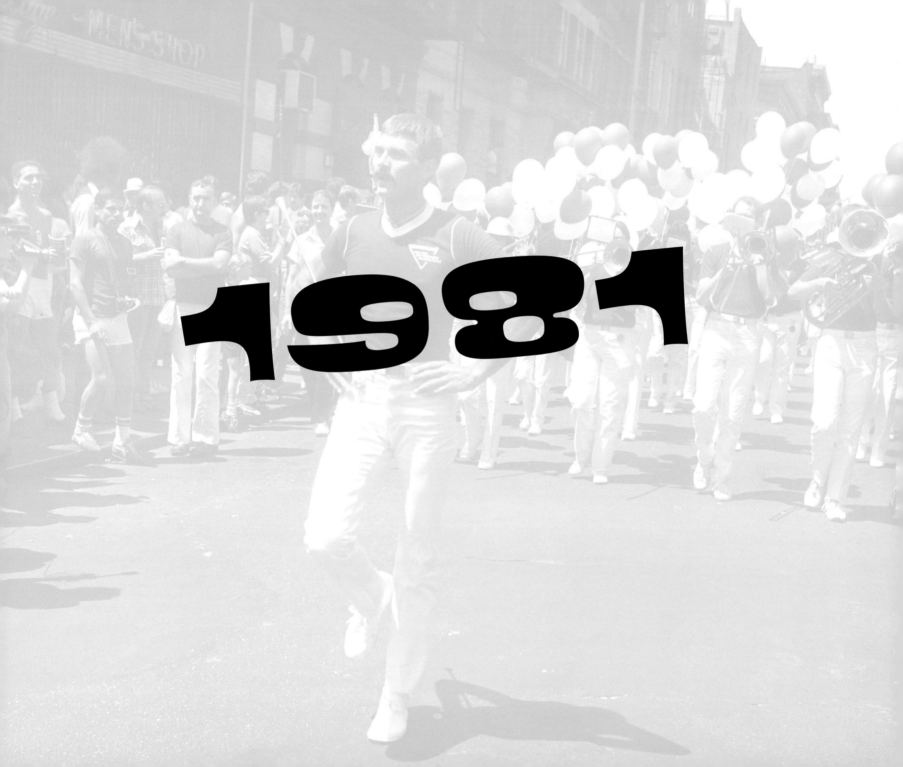

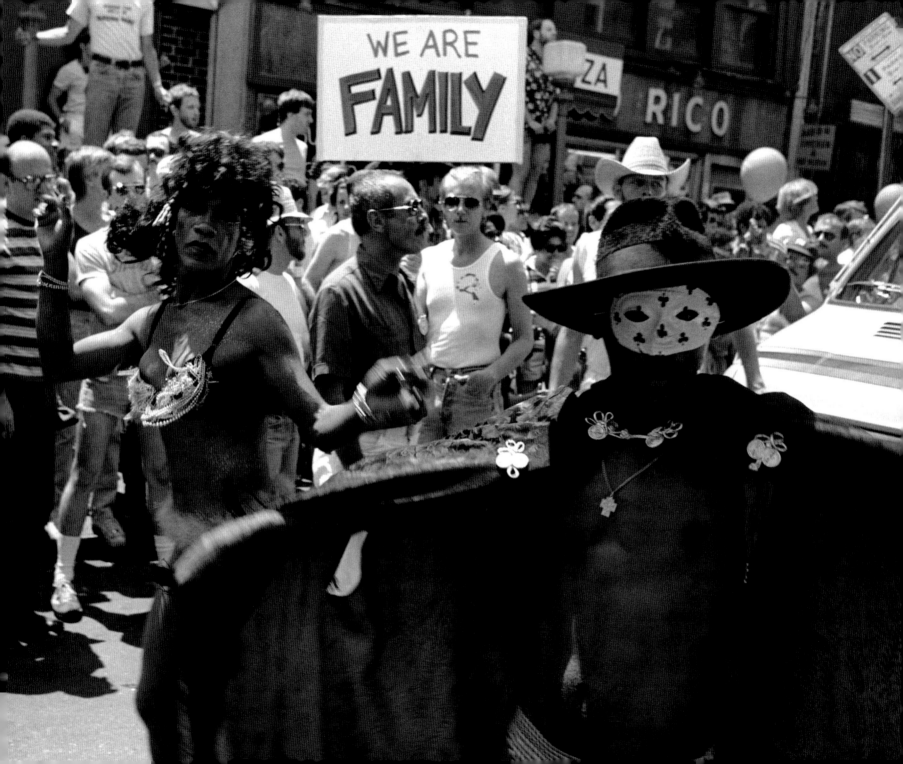

Yes he opened his cloak so we could see his black Greek statue thighs.

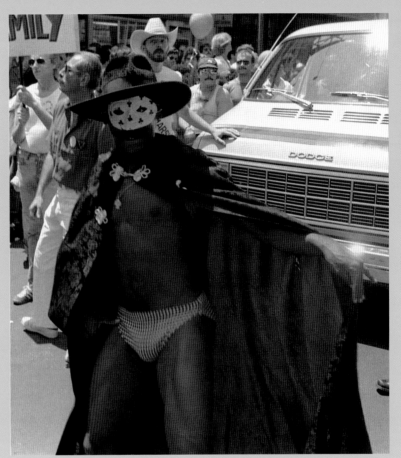

123

How can a beautiful woman like that be a man?
How can a beautiful man like that be a woman?
He's op'd his cloak to show classic torso between his nipples & belly.

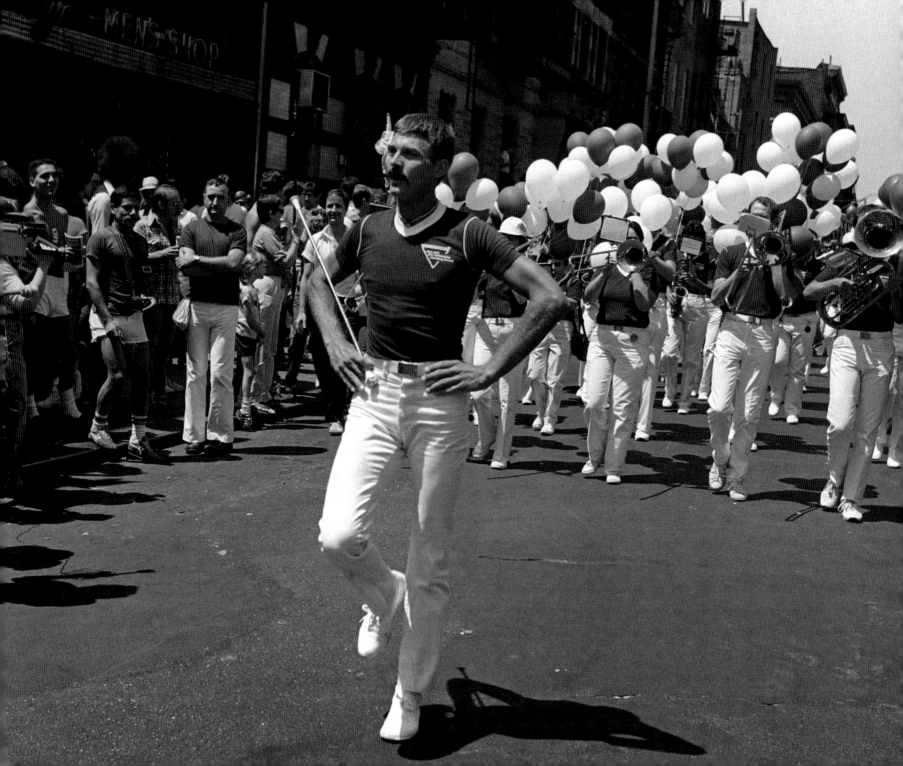

Stepping on his dwarf shadow,
trombones & balloons bobbing in midstreet air
& the sky (with folded arms) above roof cornices.

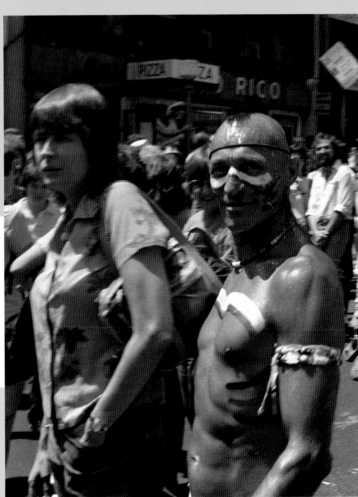

125

Painted ribs & cheekbones
he looks in your eyes,
while she slouches, hands in pocket
giant law books in her shoulder
satchel,
dreaming of Marlena Dietrich on
a horse.

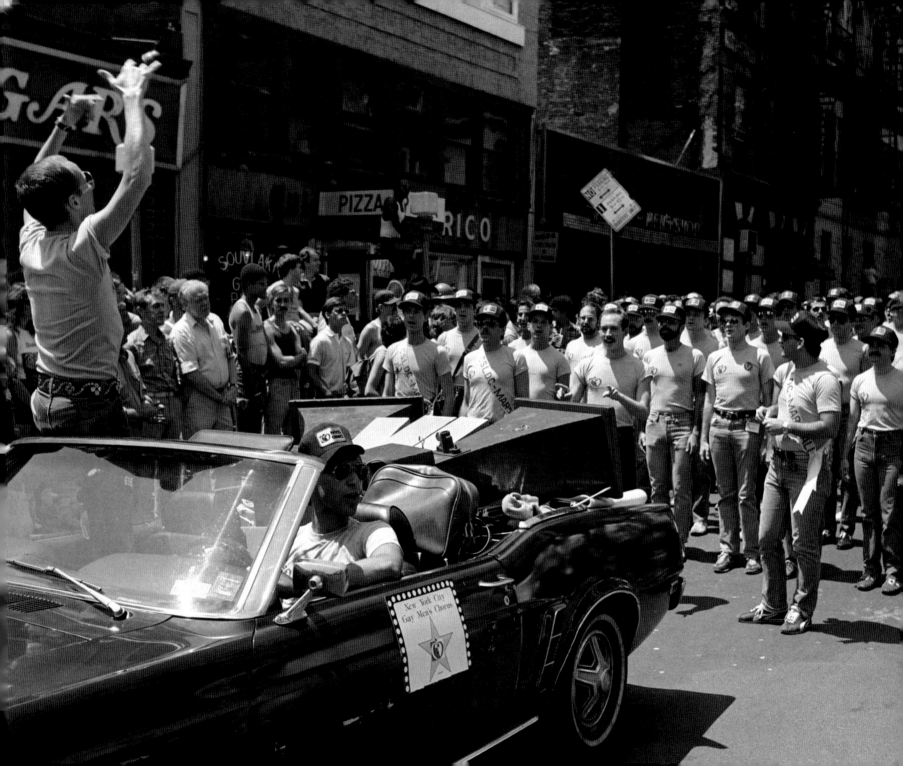

They've been meeting in secret & public
for years, & now they sing to skyscrapers.

They've been meeting in secret & public
for years & now sing to skyscrapers.

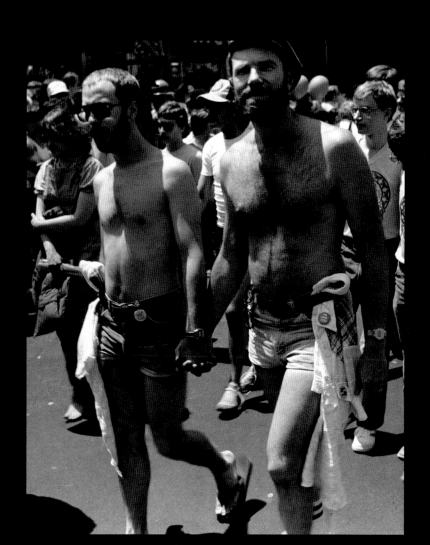

Hand in hand to face 2000
years of Moloch.

Hand in hand to face 2000
years of Moloch.

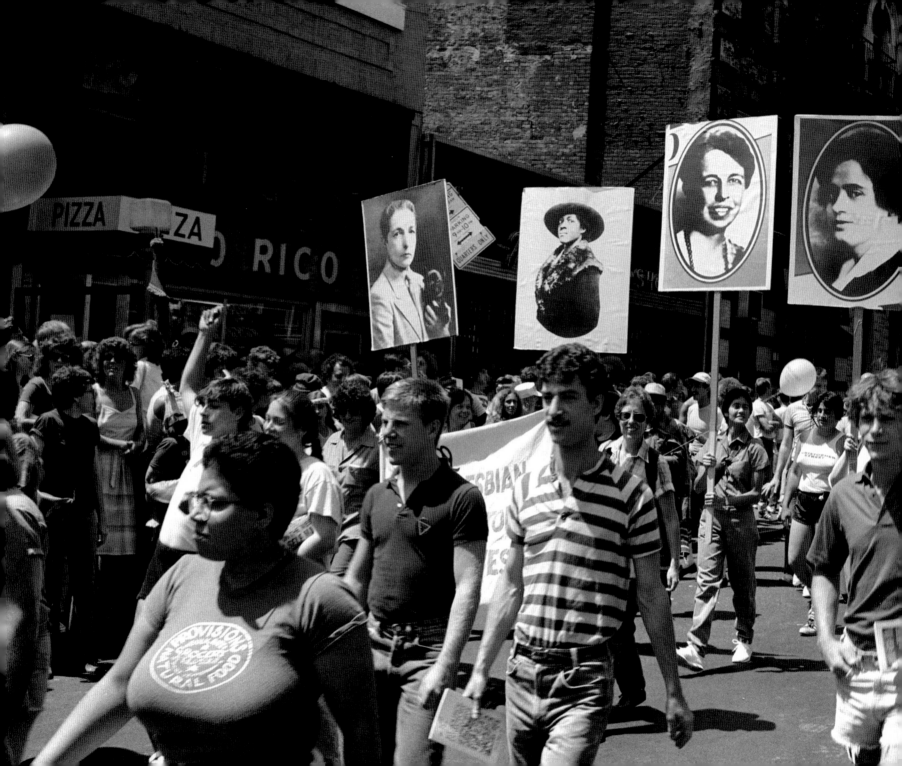

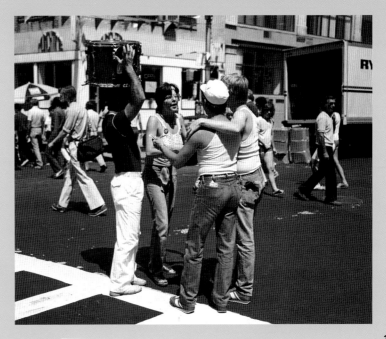

You & me & her and him & the big bass drum. Should we sell tickets to the orgy?

Eleanor Roosevelt, Willa Cather, big tits & their boys showing their schoolbooks march by fiery red brick walls.

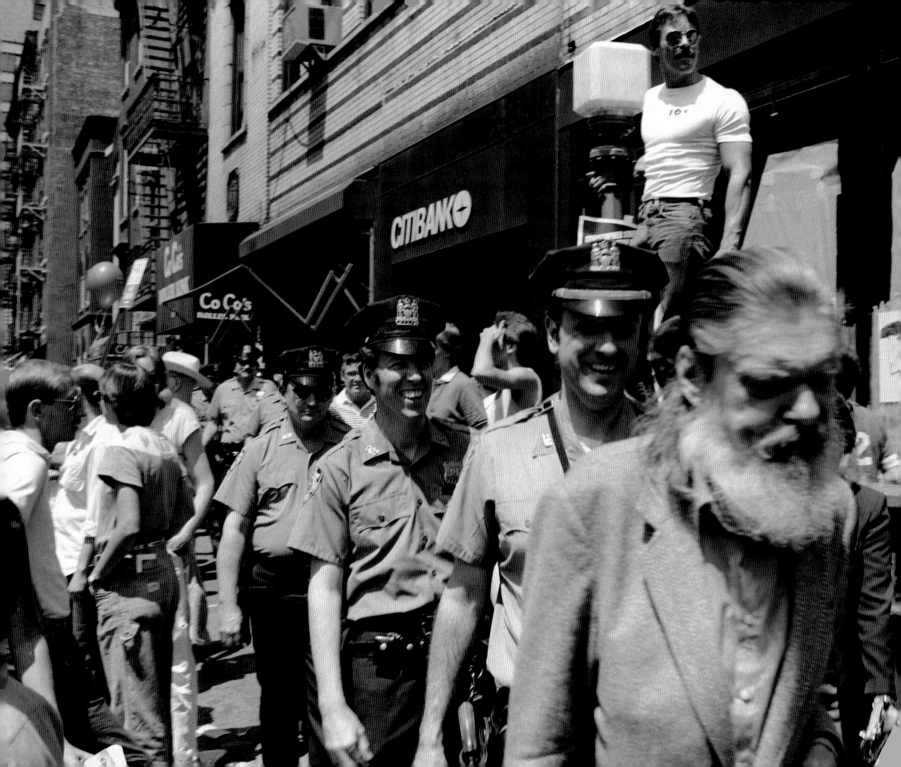

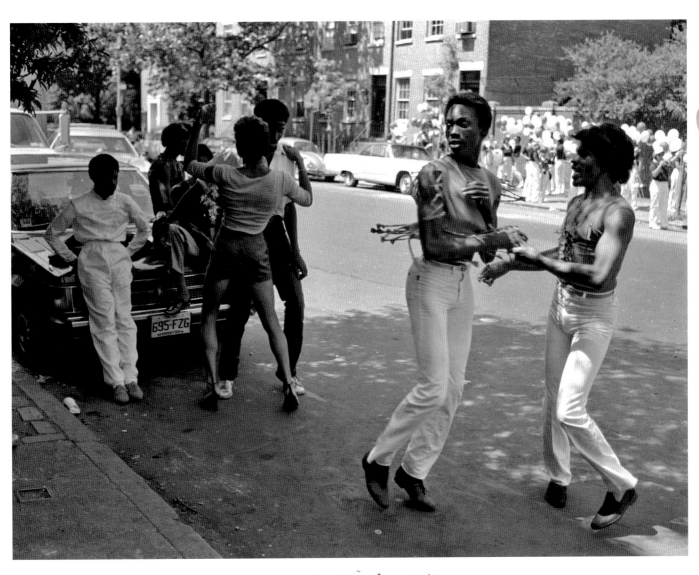

131

Yes we're at home with our big baskets
and we can sing it in the shady streele
Whose that cute strait boy in white?

Yes we're at home with our big baskets
and we can sing it in the shady street &
who's that cute strait boy in white?

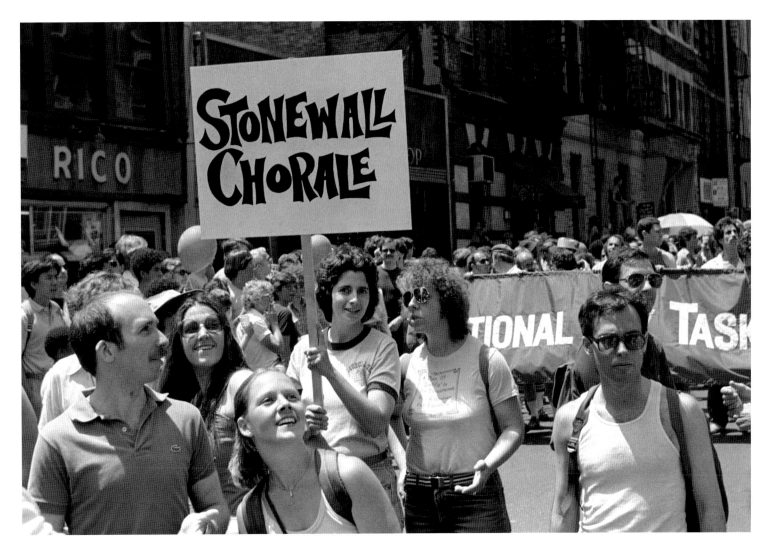

Masculine & Feminine Sopranos!
Marching on the stone
floor of Manhattan, explaining life.

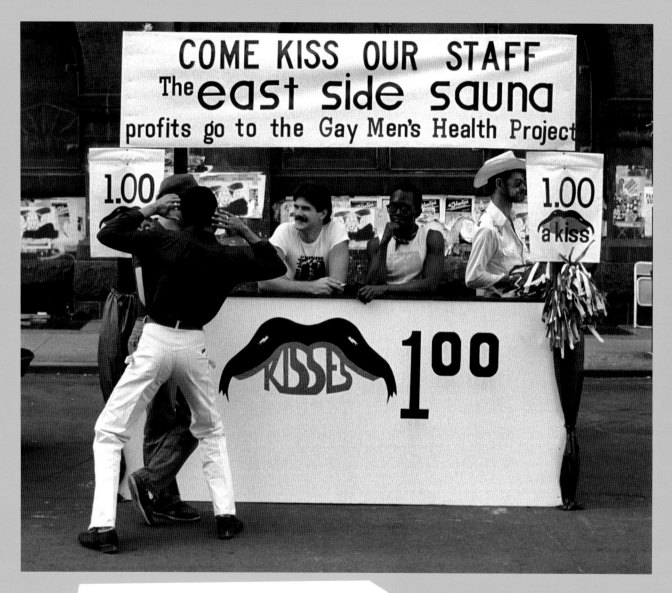

134

But ain't I worth a dollar too,
just for sticking my face out at you?

Be a Clown
for the day
Make-up - $1.00

GATHER AROUND
YOUNG AND OLD

Balloo
25

Fishing for bellybuttons, anyone?

Fishing for bellybuttons, anyone?

136

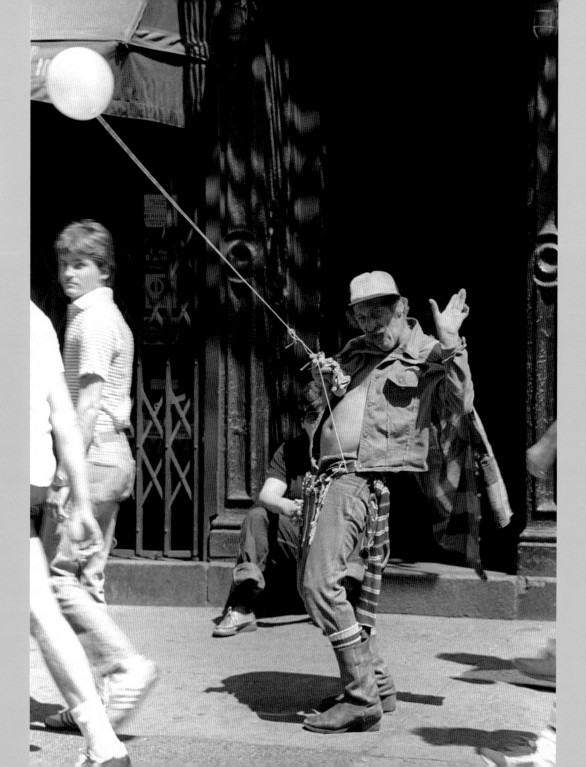

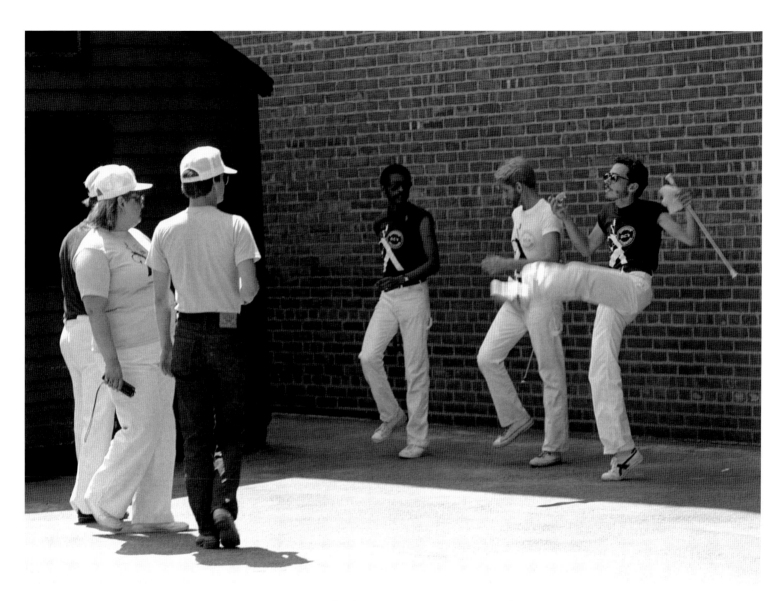

137

"We are from Stonewall, Stonewall are we
We long ago lost our virginity."

*"we are from Stonewall, Stonewall are we
We long ago lost our virginity"*

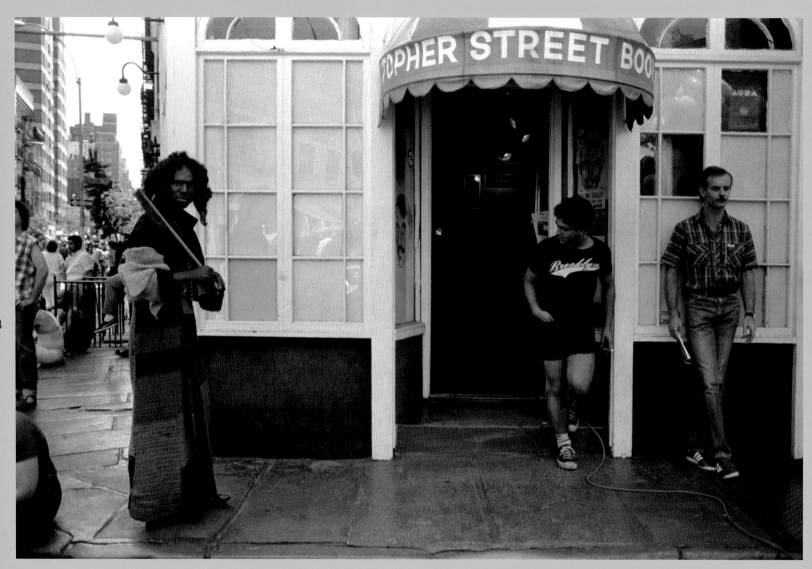

138

Look at her! Mad but actually handsome.

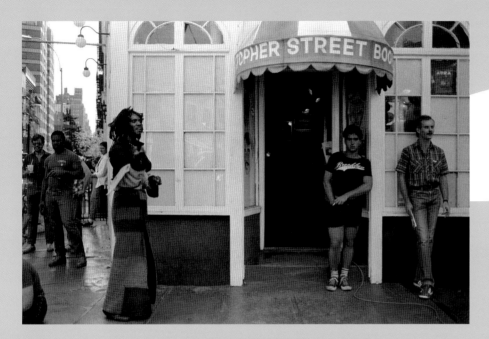

Maybe my legs are too fat. Have I got
any money?
Well my whisk broom's gone into the gutter.
I better ignore both these guys, I want
Flash Gordon's thighs.

You think I'm cute enough to . . . ?

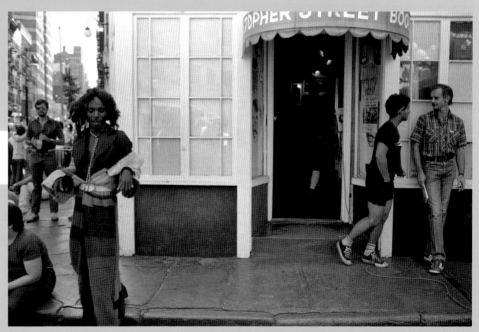

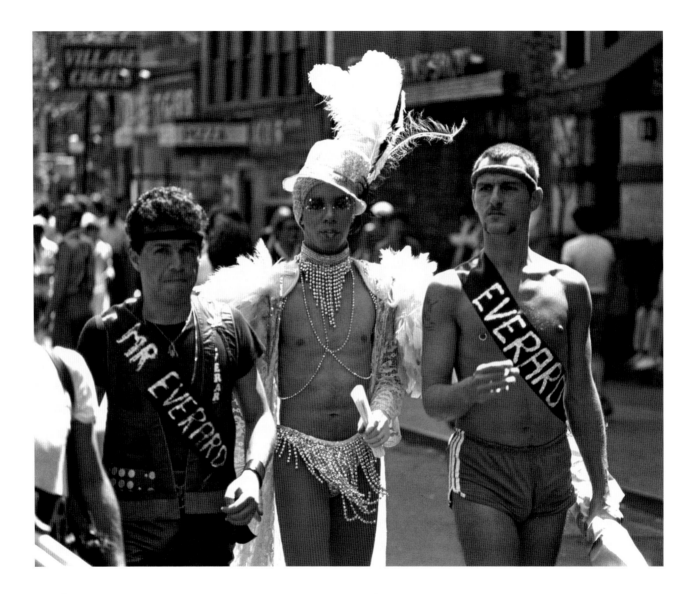

Does the Police Athletic Association still own Everard Baths? Is it really true?

Does the Police Athletic Association still own Everard Baths? Is it really true?

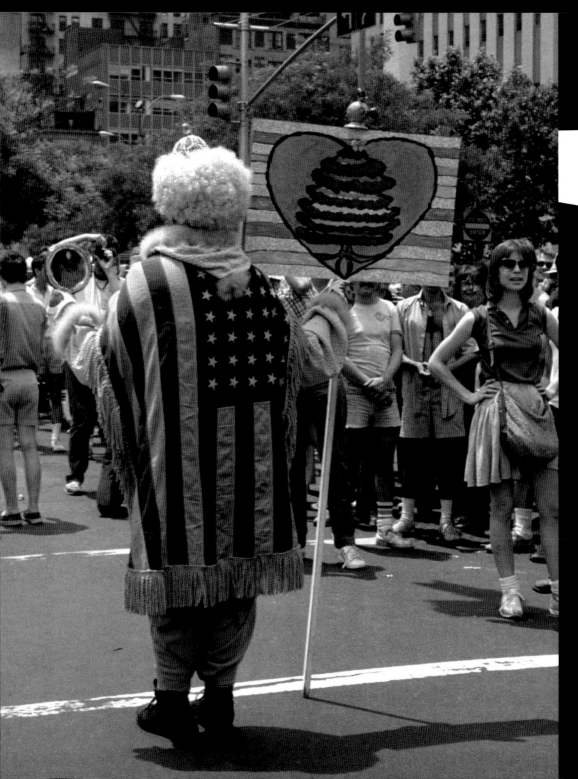

Miss American Flag with her
seven-story mountain heart
banner under apartment
buildings & fire escapes.

143

144

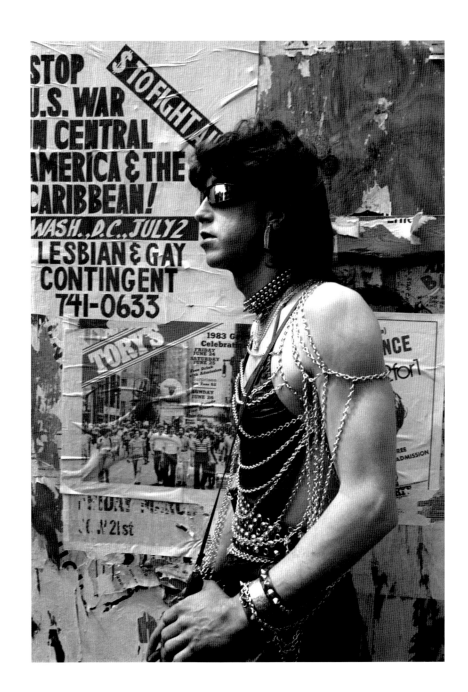

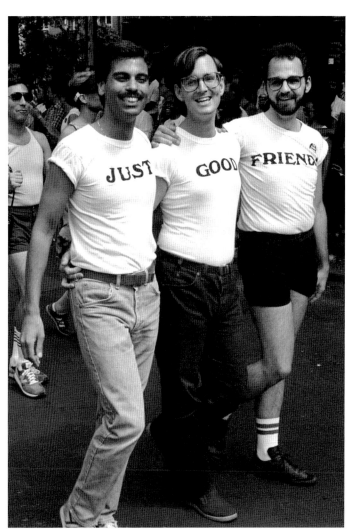

Pants down to his pubis.
"Looks like quite a consumer to me," says J. R.

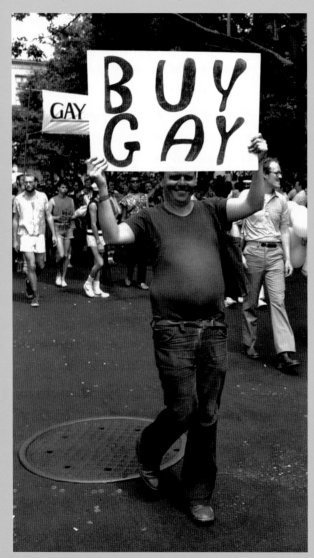

146

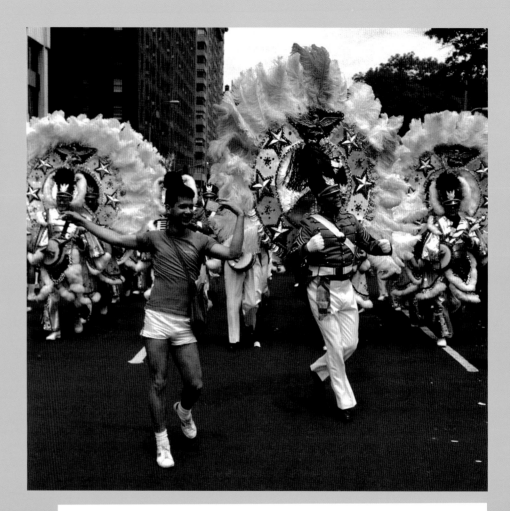

Phila mummers, feathers eagles, stars, skyscrapers,
that kid looks healthy with tough tennis legs.

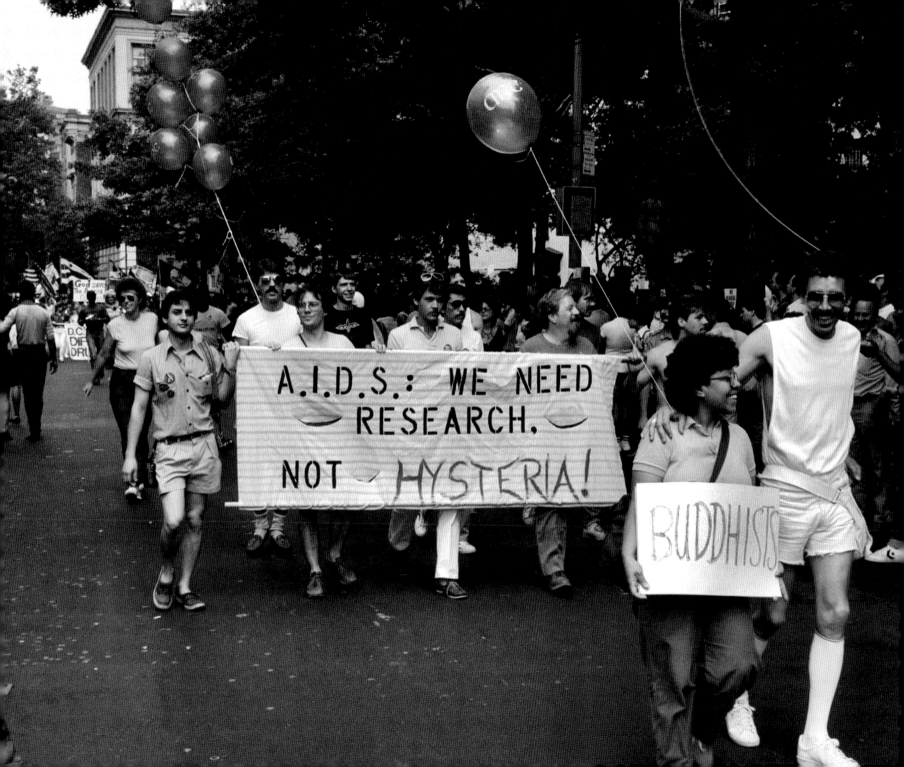

148

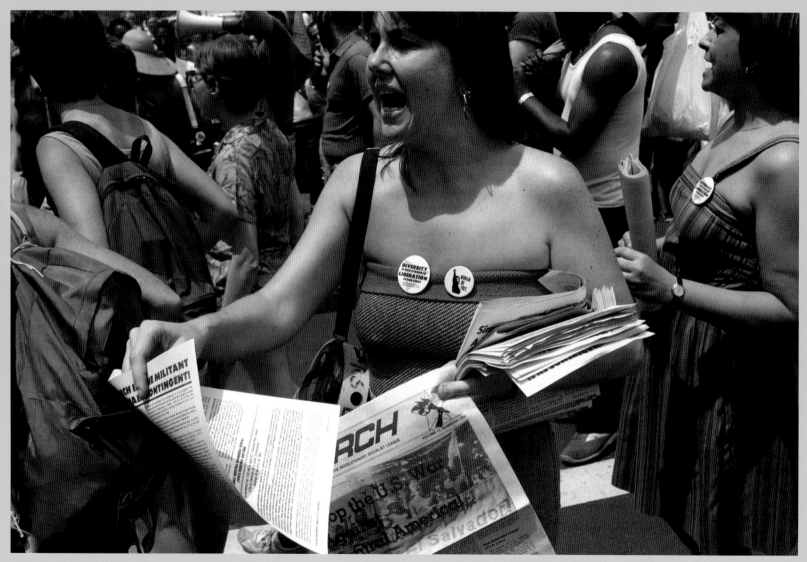

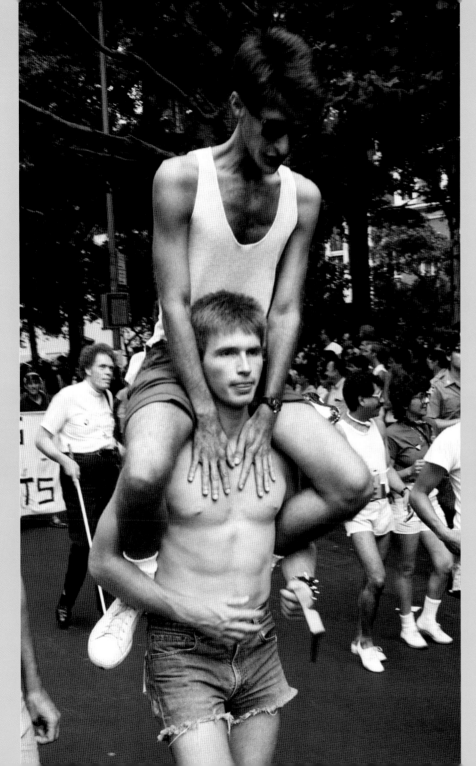

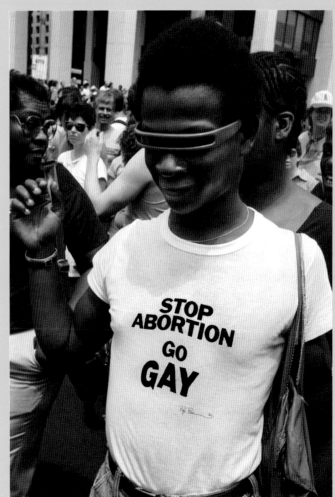

149

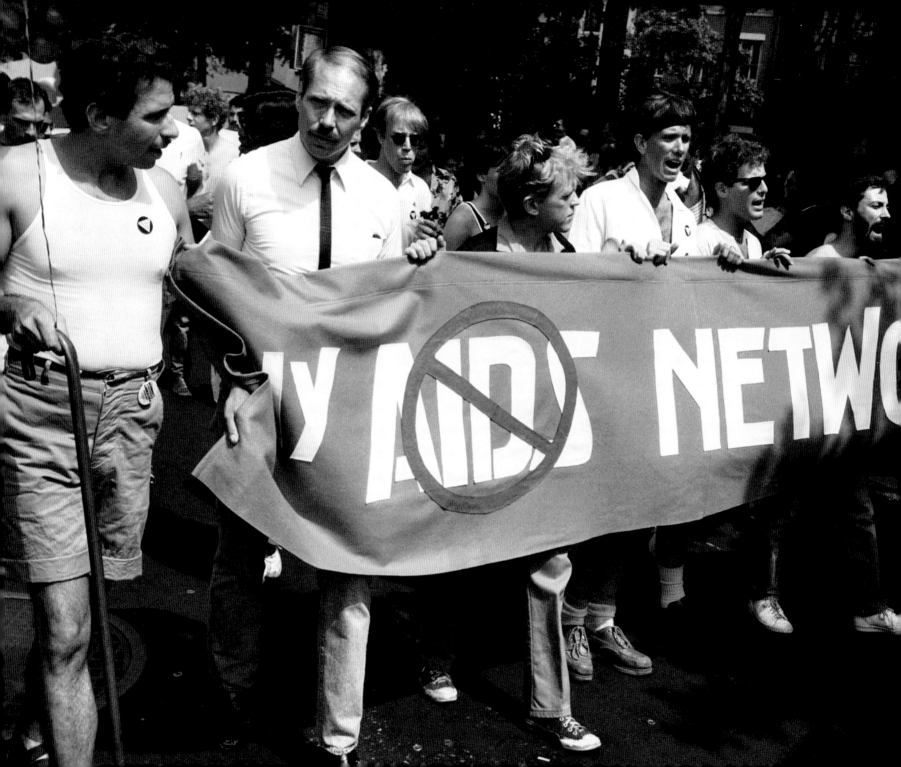

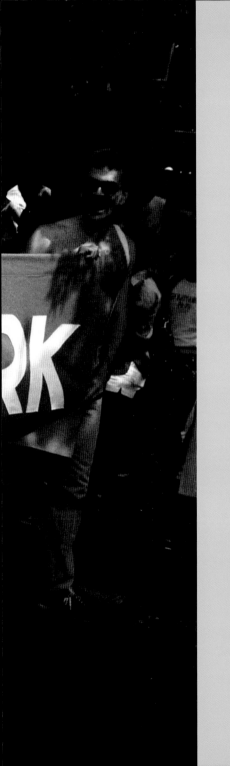
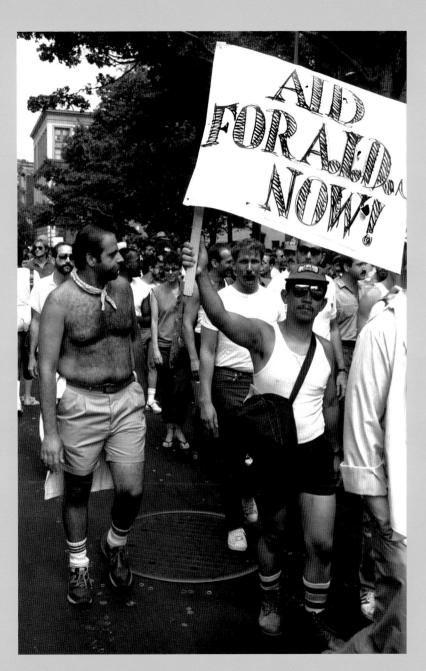
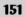

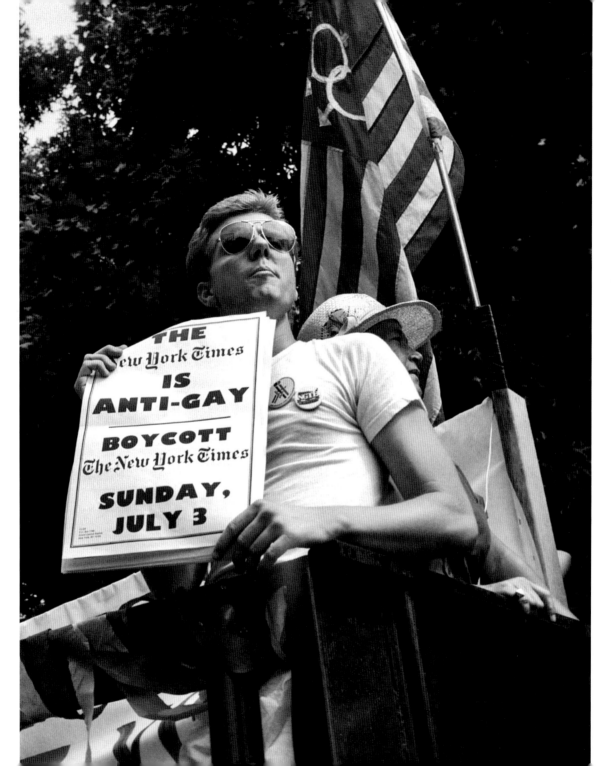

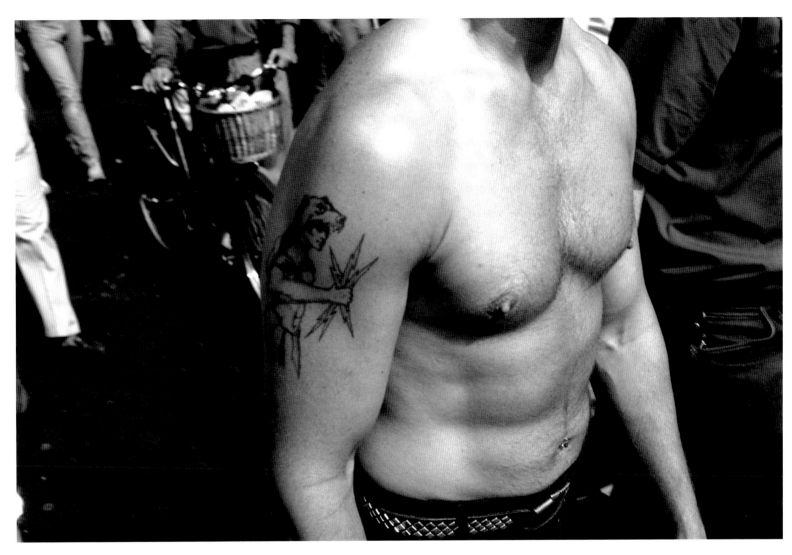

Electric ~~wolf~~ Muscle power,
big nippled ~~hairy~~ =tits,
beads in the bellybutton

Electric wolf muscle power,
big nippled hairy tits,
beads in the belly button.

Effigy of William Burroughs (preceding that of Andre Gide) carried by a strapping lad like a martial banner on The 20th Century Gay Parade past the site of Stonewall Tavern

Effigy of William Burroughs (preceding that of Andre Gide)
carried by a strapping lad like a martial banner
on the 20th Century Gay Parade past the site of Stonewall
Tavern.

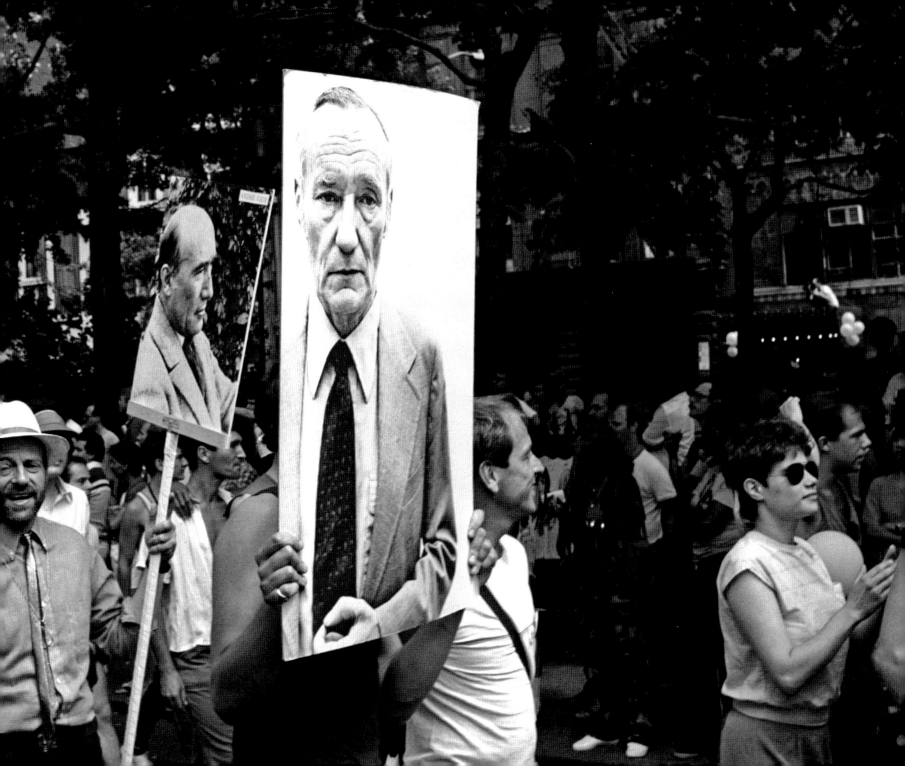

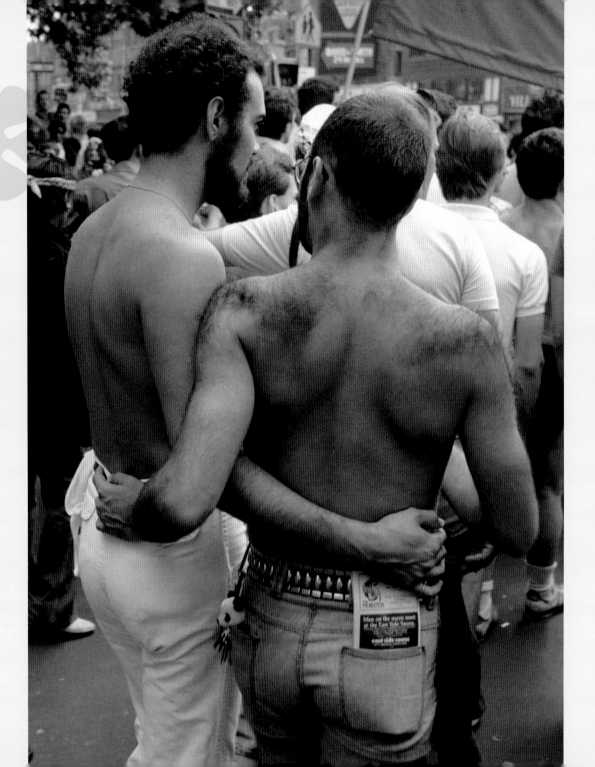

afterword

The period of 1974 to 1984, when Hank O'Neal was taking his evocative photographs of New York City's gay pride parade, was a golden age of gay and lesbian freedom. The Stonewall riots which launched the modern gay rights movement had taken place only five years before, and the AIDS epidemic was still to come (although the first cases of AIDS began to be reported in 1981, and some of Hank's photos reflect this). It was a period of innocence, of youthful exuberance, of openness, and of self-expression that gays and lesbians had never experienced before on such a scale. The closest historical parallel might be the relative freedoms of Weimar Germany before the rise of Hitler—or of certain "bohemias" such as New York's Greenwich Village in the teens or Paris in the twenties; but these lacked the public quality, and certainly the public spectacle, of American urban gay life during the ten years that Hank was taking his photographs.

The gay revolution began on a steamy night in June 1969 when a group of gay men—many of them drag queens—rioted during a police raid on the Stonewall Inn, a popular bar in Greenwich Village. For years, such raids had been standard operating procedure for the police in New York and other cities across the nation. Until the mid-sixties, the New York State Liquor Authority was authorized to close bars and taverns that served homosexuals; in many states it was illegal for same-sex couples to dance together; and private, consensual gay sexual behavior was illegal in all fifty states. But on the night of June 28, 1969, for the first time, large numbers of gays fought back against police harassment. By the next evening, another crowd faced off against the police, hurling bricks and bottles, and shouting "Gay Power." As Allen Ginsberg said in his famous remark a few days after Stonewall, "You know the guys there were so beautiful—they've lost that wounded look that fags all had ten years ago."

That "wounded look" had persisted for as long as anyone could remember. Until Stonewall gay men and lesbians barely existed as an identity or made up a measurable group. They were perceived as just a number of mostly unconnected individuals that religious institutions denounced as sinners and the American Psychiatric Association's diagnostic manual listed as suffering from a mental disorder (this classification was removed in 1973). In the aftermath of Stonewall—and influenced by the social and political currents of the sixties, to say nothing of the "sexual revolution"—gay became something to celebrate, not to be ashamed of or to hide. Organizations like New York City's Gay Liberation Front, Gay Activists Alliance, and Lesbian Feminist Liberation emerged, their radicalism replacing the more cautious tactics of the pioneering homophile organizations of the fifties and sixties, which failed to have a significant impact on the wider gay population. There were gay and lesbian manifestos, weekend alternative dances, and "zaps," in which activists confronted politicians, the media, and other institutions. It was the era when terms like "come out," "closet," and "consciousness-raising group" entered the language. Just as African Americans had taken the word "black" to characterize their new-found pride and self-affirmation, the word "gay" replaced the clinical term "homosexual" and derogatory terms like "queer" and "pervert." (For women, "dyke," the ultimate pejorative, was transformed into a positive expression).

On the first anniversary of Stonewall, June 28, 1970, New York held its first gay pride parade, in which somewhere between 5,000 and 20,000 marched from Greenwich Village to Central Park. The event would

157

have been unthinkable just a year before; Chicago and Los Angeles held similar events that year. Gay liberation may have been the last of the social and political movements of the sixties to emerge, but the invisibility that had characterized gay people in the past was breaking down with surprising speed. *The Village Voice* described that first parade this way:

They stretched in a line, from
Gimbels to Times Square,
thousands and thousands and
thousands, chanting, waving,
screaming—the outrageous and the
outraged, splendid in their flaming
colors, splendid in their
delirious up-front birthday
celebration of liberation . . .
No one could quite believe it,
eyes rolled back in heads,
wondrous faces poked out of
air-conditioned cars. My God,
are those really homosexuals?
Marching? Up Sixth Avenue?

Gay pride parades would become an annual gay community ritual—Fourth of July, Thanksgiving, and Memorial Day rolled into one. It was the day when you saw everyone who was invisible—or shut up in his or her own separate gay world—during the rest of the year: drag queens, leather queens, working-class gays and gays of color, suburban householders and outer borough "disco bunnies," and the ubiquitous "dykes

on bikes." By the next decade, there would be parades in less obvious places such as Louisville, Kentucky; Des Moines, Iowa; Worcester, Massachusetts; and eventually in cities around the world from Johannesburg to Jerusalem.

By the early seventies, a rich community life was evolving: There were gay bookstores and publishing houses, volleyball and softball teams, cafes and restaurants, choruses and marching bands, churches and synagogues. Gay men were gentrifying urban neighborhoods from San Francisco's Castro to Boston's South End. By the middle of the decade, almost every city from Seattle to Pittsburgh to Portland, Maine, had its own gay newspaper. (*The Los Angeles Advocate*, established in 1967, anticipated this, later dropping "Los Angeles" from its name and becoming a national magazine.) The exodus of gay people from small towns and cities to gay-friendly urban centers, first observed in the aftermath of World War II, became a virtual flood tide.

Within a few years, much of the counterculture flavor—and exhilaration—of those early days faded, replaced by a more mainstream movement trying to achieve pragmatic political goals. The gay revolution had become the gay rights movement. The first national advocacy organization— then called the National Gay Task Force— was established and pushed hard for the passage of anti-discrimination protections and the repeal of laws criminalizing gay sex. By the middle of the decade, some

forty U.S. cities—including Los Angeles, Minneapolis, and Washington, D.C. (but not New York City until 1986)—had enacted gay rights ordinances. In 1974 Elaine Noble was elected to a seat in the Massachusetts House of Representatives, becoming the nation's first openly gay legislator; in Minnesota, first-term State Senator Allen Spear followed in her footsteps. In San Francisco, a camera store owner named Harvey Milk was elected to that city's Board of Supervisors as an openly gay candidate, another first. Air Force Technical Sergeant Leonard Matlovich announced that he was gay in a challenge to the military's ban on homosexuals within its ranks, and made the cover of *Time*. (In newspaper headlines, public figures no longer "admitted" they were gay, they "announced" it or "proclaimed" it.) Even a former National Football League running back, Dave Kopay, revealed his homosexuality. Granted, he was no longer playing professional football—that would have been too audacious—but he turned stereotypes upside down just the same. Male professional sports would remain the last taboo.

And then, just when the momentum appeared unstoppable, a counterrevolution emerged. The organized opposition came from an unexpected quarter— Anita Bryant, pop singer of another era, former Miss Oklahoma, and pitchwoman for Florida orange juice. In early 1977, after Dade County (Miami), Florida, had

passed an ordinance banning discrimination against gays and lesbians, Bryant formed an organization called Save Our Children, Inc., to force a county-wide referendum on the new legislation. "Gays don't reproduce, they recruit," she charged. Her arguments were ridiculous to anyone who knew anything about the gay community, but they clearly resonated with voters who were having difficulties accepting the decade's rapid pace of social change; the ordinance was repealed by more than a two-to-one majority of Dade County voters.

Bryant immediately became a lightning rod for gays and lesbians around the country. A boycott of Florida orange juice gained steam, as activists tried to get her fired as the spokesperson for the Florida Citrus Commission. She became a target of ridicule—a gay activist hit her in the face with a banana cream pie at an anti-gay rally in Des Moines. At gay pride parades, caricatures and effigies of her were commonplace. One of Hank's photos shows a group of marchers holding aloft a giant cutout of Bryant, featuring a Hitler-style mustache and a swastika armband. In June 1977, the month the Miami ordinance was repealed, gay pride parades around the country boasted the largest crowds ever, due in part to outrage over Bryant and the rising anti-gay tide.

Anita Bryant soon withdrew from the scene, a political neophyte who had been perhaps manipulated by political and religious forces larger than herself. She was an easy target—too easy perhaps. The back-lash continued. Gay rights ordinances were repealed in St. Paul, Minnesota, and in the liberal college town and hippie haven of Eugene, Oregon. The Briggs Initiative—a proposal to ban gays and lesbians from teaching in California schools—failed at the ballot box in that state, though it required a major organizing effort to defeat it. (The opposition of Governor Ronald Reagan, bane of AIDS activists in later years, helped save the day.) If gays were going to keep the rights they had—and gain additional legal protections—it was clearly going to be an ongoing struggle.

Then, in the fall of 1978, Harvey Milk, the popular, openly gay member of the San Francisco Board of Supervisors, was murdered, along with Mayor George Moscone. The assassin was another city supervisor, Dan White. Although obviously a troubled individual, White represented another face of the backlash: the grievances of the city's white working class and their fears that they were losing control of their city to people—not only gays—whose values appeared alien or foreign. When White was found guilty only of manslaughter—the result of the infamous "Twinkie defense" that blamed his murder spree on his consumption of junk food—demonstrators burned police cars and the police rampaged through gay bars in what became known as the "White Night Riots." And Harvey Milk became a gay martyr, probably the most famous since Oscar Wilde.

Despite the need to resist the back-lash, unity within the gay community was elusive. Gay men and lesbians created two very different cultures in the seventies that rarely met, except once a year at gay pride parades. Lesbians tended to forge alliances with other women—and with the burgeoning feminist movement—rather than with gay men. Separatism was a powerful force. There was an effort to create a utopian women's culture, one more in line with the countercultural values of the sixties, even as these values faded out in the rest of society. Women's music, with its concerts and festivals, helped hold the culture together. Serial monogamy was, generally speaking, the lesbian way of love and sex. In the view of some, you didn't even have to have sexual relations with another woman to be a lesbian—all you had to do was identify with women and the lesbian-feminist culture.

By contrast, for many gay men, their newly won sexual freedom provided the basis of their identity. For a large portion of the community, social lives revolved around bars, the baths, and sex clubs like New York City's Mineshaft and the Anvil. This was very much in keeping with an era in which the sexual revolution had made deep inroads into American society. Of course, there were men who lived in monogamous relationships, especially those outside large urban areas, but they seemed marginal to a gay male culture that was shifting increasingly into the fast lane. In his 1980 book *States of Desire*, Edmund

White describes New York City gay life this way: "Sex is casual, romance short-lived; the real continuity in many people's lives comes from their friends."

Then, in the early eighties, this sexual culture that many gay men had created faced something far more serious than political backlash—the advent of AIDS. The disease was first seen in gay men as early as 1981, when it was dubbed "Gay-Related Immune Deficiency (GRID)" and the "gay cancer." By 1983 Larry Kramer was writing his passionate essay "1,112 and Counting," warning that, "Our continued existence depends on how angry you can get." (The year before, Kramer had helped to start New York's Gay Men's Health Crisis, the AIDS service organization that would be duplicated all over the country.) It was a particularly uneasy and frightening time. No one knew how AIDS was spread—could it be transmitted by kissing, food handling, casual contact?—or what caused it. Many in the community feared quarantine. The right wing exulted: "The sexual revolution has begun to devour its children," wrote Pat Buchanan, in his syndicated column. By 1983, HIV was determined to be the cause of AIDS, and some studies showed that 50 to 60 percent of sexually-active gay men in New York City and San Francisco were infected with the virus; but there was still no cure and no treatment. The battle over whether to close San Francisco's bath houses took center stage and the baths were shut down. The entire tenor of gay life slowly began to shift—to look more inward, toward taking care of its own. When it looked outward once again, it would be intensely political, demanding more and better HIV drugs, more quickly and cheaply. In Act Up and organizations like it, lesbians and gay men became allies; the Names Project's AIDS Memorial Quilt, first unveiled at the gay march on Washington in 1987, came to symbolize a caring community that engendered wide public sympathy for the first time. AIDS became everyone's problem—not just a gay one—and safer sex became recognized as the most realistic way to fight the disease.

With the arrival of AIDS, much of the carefree quality that one sees in Hank O'Neal's earlier photos begins to fade. Today, looking at the men he photographed, the viewer cannot help but wonder how many of them are still alive, how many survived the plague years. The euphoria and the innocence of the decade after Stonewall has become a memory, replaced by a determined sense of survival. In the photos, what stands out is a sense of resilience that enabled the gay community to triumph over adversity. An interesting and unexpected pattern emerged. As much as many people thought that the counterrevolution of the Anita Bryant years would weaken the new movement, the opposite occurred. The backlash encouraged more and more people to come out of the closet, creating a second wave of visibility. Similarly, although at first it seemed that AIDS would destroy gay male life, instead, the result was an outpouring of support and activism that expanded and deepened the gay community, opening the way to gay marriage and parenting. The golden age that Hank O'Neal photographed on Gay Pride Day in the seventies and eighties is gone, like all golden ages; for those who survived, what took its place was something harder to capture in a photograph—the often-painful wisdom of experience.

Neil Miller